PRESTON
IN
50
BUILDINGS

KEITH JOHNSON

AMBERLEY

First published 2016

Amberley Publishing, The Hill, Stroud
Gloucestershire GL5 4EP

www.amberley-books.com

British Library Cataloguing in Publication Data.
A catalogue record for this book is available from the British Library.

ISBN 978 1 4456 5897 1 (print)
ISBN 978 1 4456 5898 8 (ebook)

Typesetting and Origination by Amberley Publishing.
Printed in Great Britain.

Contents

Preface

Preston became a city in 2002, over 200 years after the first cotton mill had been erected in the town. What followed that first mill were years of development that left us with a university city.

Daniel Defoe, the author of *Robinson Crusoe*, toured the nation in the early eighteenth century as a prelude to his three volume travel book *Tour Through the Whole Island of Great Britain (1724–27)*, which provided a fascinating first-hand account of the state of the country. Regarding Preston, he had this to say: 'Preston is a fine town, but not like Liverpool or Manchester. Here's no manufacture; the town is full of attorneys, proctors, and notaries. The people are gay here and though non the richer for it; it has by that obtained the name of Proud Preston.'

He had been particularly impressed by Fishergate and Church Street – then called Churchgate – remarking thus:

> The great stretch is filled with great houses and is very broad. The house of the present Earl Of Derby makes a noble appearance, and in general the houses are very well built. To this town the gentry resort in the winter from many miles around, and there are, during the season, assemblies and balls in the same manner as York.

Fine words indeed, but things would certainly change in the centuries ahead while the Preston of today was created. It involved great feats of civil engineering, far-sighted architects and people intent on progress.

The buildings of any town or city define the place more than anything else and Preston is no exception. The skyline is inevitably dominated by the tallest of structures and the main highways through Preston were shaped by the erection of the earliest dwellings and footpaths. It never is a blank canvas for the developer, but one where the existing landscape cannot be ignored.

The choice of fifty existing buildings is no easy task, for we all have those to which we attach fondness or favour. Those selected have been chosen for reasons of either social, commercial, historical, political or civil importance, or simply because they are civil engineering feats to admire.

They all, in their own way, reflect the drive and ambition of people to improve the environment for Preston folk to linger, dwell, or work within. Hopefully, you will appreciate what was no mean achievement to create a city; although with hindsight it probably didn't turn out quite like the town the planners of old foresaw or dreamed about.

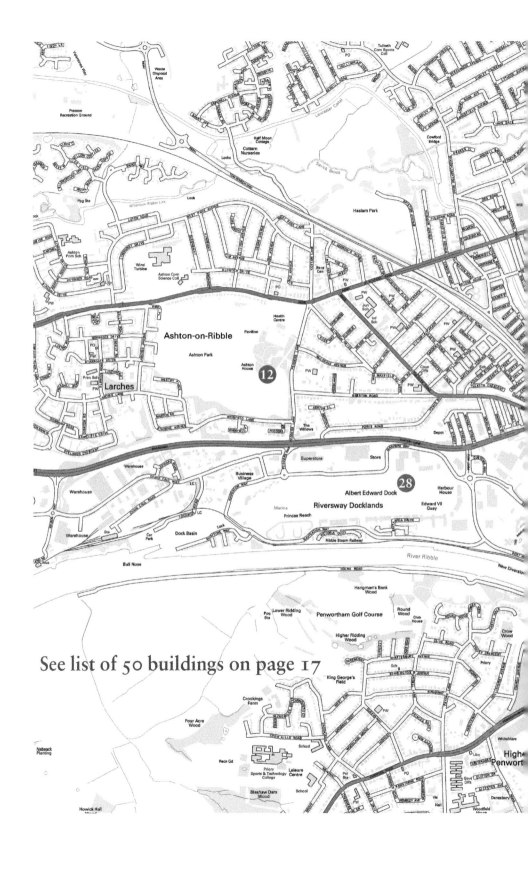

Ashton-on-Ribble

Larches

Ashton Park

Ashton House

(12)

(28)

Albert Edward Dock

Harbour House

Riversway Docklands

Edward VII Quay

Marina

Princes Reach

Dock Basin

Ribble Steam Railway

Bull Nose

River Ribble

New Diversion

Hangman's Bank Wood

Lower Ridding Wood

Penwortham Golf Course

Round Wood

Club House

Crow Wood

Higher Ridding Wood

Priory

See list of 50 buildings on page 17

King George's Field

Crookings Farm

Four Acre Wood

Nabsack Planting

Recn Gd

Priory Sports & Technology College

Leisure Centre

Blashaw Dam Wood

School

School

High Penwort

Howick Hall

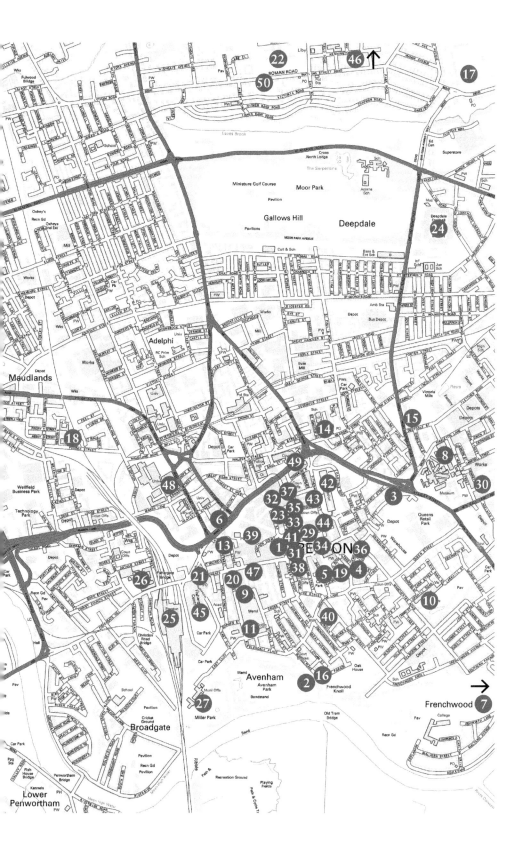

Introduction

A glimpse at George Lang's map of 1774 shows us there was much progress ahead. Only three years later Messrs Collinson & Watson were building the first cotton factory in the town – in the Moor Lane area.

According to the Preston City Council website there are around 770 listed buildings and structures in the city, ranging from the Grade I Harris Museum and St Walburge's Church to structures such as the Grade III milestones on the Garstang Road.

Only a handful of those listed have origins in the seventeenth century, while those preserved from the eighteenth century number some twenty-five, including the historical obelisk of 1782 that was dismantled in 1853, but returned to the Market Place in 1979 upon a fine new pedestal to mark 800 years of Royal Charters.

Considering the rapid growth of the cotton and engineering industries in the town in the nineteenth century, it is no surprise that many listed buildings remain from that era. There were cotton mills aplenty, along with factories and workshops, all built to fuel the industrial development.

As the factory workers arrived they needed shelter and in addition to cottage homes, rows of terraced houses were erected. A report in the *Builder Magazine* of 1861 painted a

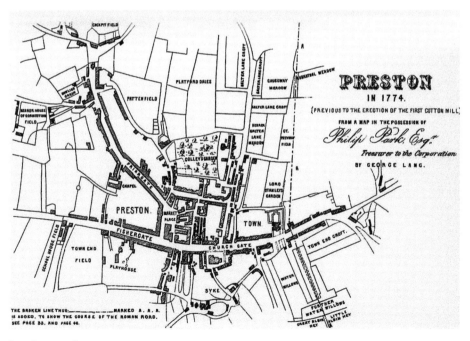

Lang's map of 1774.

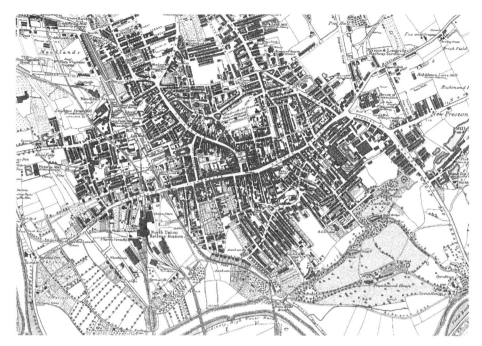

Map of Preston in 1844 with building progressing.

dreary picture of Preston as a town coming to terms with its emergence as a manufacturing place, remarking thus about the cotton trades effect:

> The factories are oblong packing cases of bricks and mortar, pierced with oblong window openings and shooting up from these tasteless blocks are tall chimney shafts. Grouped with these are rows and rows of habitations for the workers. Nothing plainer could be perceived. Directly a factory has been planted down, the land has been turned up for brick earth, a kiln started, bricks manufactured and poor houses built.

Nonetheless, having been a dwelling place for those of high society, Preston had a taste for fashionable property and the masters of the mills, lawyers and bankers carried on the tradition, with many a mansion emerging amid the grime and grit.

In the mid-1600s the population of Preston was around 5,500. It had grown to over 12,000 by 1800 and by 1845 it was 58,000 – more people, more buildings required. This was reflected in the Avenham area which was particularly well populated by the mid-1840s; the New Hall Lane area began to grow outwards along with Fishwick as cotton mills and workshops appeared. Highways were developed to reach the mills and terraced homes. A row of cotton mills at the northern extremity of town, comprising of the Brookhouse Mill, Ox Heys Mill, Green Bank Mill, Moor Brook Mill and Brookfield Mill, led to green pastures beyond.

Inevitably, since there were over seventy cotton mills at times, several still survive dotted around the city. Some of these surviving buildings are still used for manufacturing, services, storage or leisure pursuits. Among them are the Spittall Moss factory on Fylde Road, built by John Horrocks c. 1794; the old Daniel Arkwright mill on Greenbank Street; the

Spittall Moss factory on Fylde Road.

Aqueduct Street Mill, once owned by Calvert & Co.; and the Shelley Road Mill, now used by Plumbs the fabric suppliers.

It wasn't all about the cotton mills though as other great factories arose, for example on Strand Road which is where carriages, trams and aeroplanes were built. The plane-makers may have flown away to Warton & Salmlesbury, but some of their old premises remain: the vast Dryden Engineering Works on Grimshaw Street; the old Gold Thread Works buildings on Avenham Road; and in Cotton Court on Church Street there still stands a tall renovated building that was once part of Starkie's Steam Wire Works, c. 1842.

By the 1830s a great church building programme was under way with church towers and spires appearing at St Peter's, St Paul's, Christ Church, St Mary's, St James' and St Thomas' for those of the Church of England faith. The Roman Catholics had added St Ignatius and St Augustine's to their list. While the Noncomformists added a chapel in Lune Street, the Orchard chapel, the Saul Street chapel, the Grimshaw Street chapel and the North Road Wesyleyan chapel in a period of growth.

A new parish church known now as the Minster, St Walburge's with its spire, and English Martyrs in the Gallows Hill area are among the many more that followed down the decades. Nowadays the churches have been joined by the mosques and temples of other faiths in a multi-cultural society.

Following the decline in congregations, over recent decades a number of older church buildings have been saved from demolition. St Marks' is now an apartment block, St Paul's

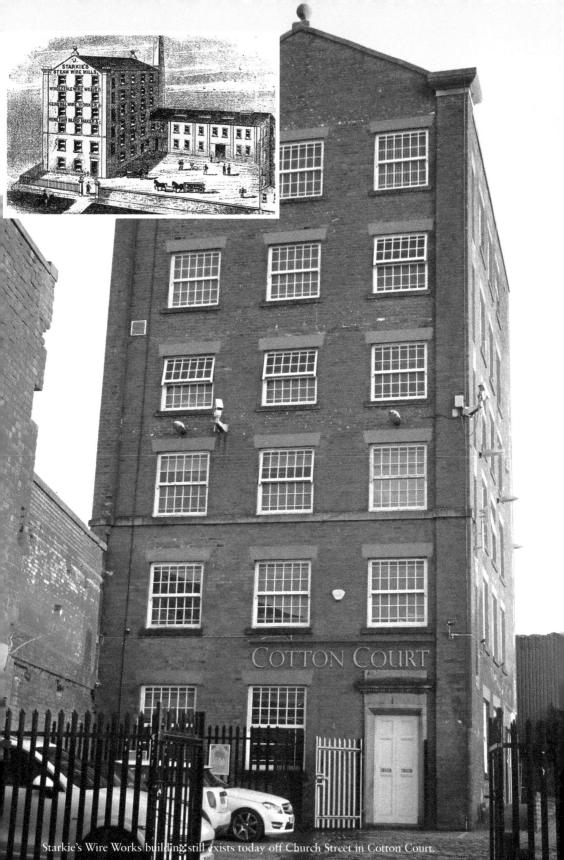

Starkie's Wire Works building still exists today off Church Street in Cotton Court.

a home for a radio station, St Luke's a place of refuge, and St Peter's an Arts Centre on the University of Central Lancashire campus. Make no mistake, these are all fine buildings and, thankfully, patiently restored and renovated.

With the churches and chapels came numerous places for the education of the working class children – Sunday Schools & Ragged Schools. Great strides were made from the time St Wilfred's opened their Fox Street School in 1817 to join the National School on Syke Hill (opened in 1814) which had roots in the Blue Coat Charity School in Main Sprit Weind (begun in 1701). Lots more church school buildings followed and generations were taught in the parish premises.

The education systems were changing in the mid-1950s, and in 1957 it was announced that the Ashton-on-Ribble County Secondary School was opening after a £212,000 spend – many more would follow. Preston has tried to keep pace, with the old grammar schools and colleges developing into sixth form colleges.

Inevitably, as the population increased the inns and the taverns increased accordingly, with many of them located where the millworkers lived. These were the days when the Moor Park Inn, Doctor Syntax, the old Wheat Sheaf Inn, and the Fox & Grapes on Ribbleton Lane, all built in subsequent years from 1836, were almost regarded as out of town.

The landscape of pasture, meadow and windmills was changing fast, yet amazingly, a single trace of the windmill days remain on Moor Lane – the Craggs Row windmill of 1760. It may be bereft of sails, but it still stands proudly as a glimpse into the past.

The Lancaster Canal weaved its way through town from 1798 to transport goods and passengers. This was followed by the first railway link with Wigan, opened in 1838, and eventually those old stagecoach routes would be turned into highways. The building of bridges, aqueducts and railways left a legacy of structures quite unique in their day.

Commerce played its part with saving banks, shops and offices eventually being provided by necessity. Undoubtedly the bankers left us a legacy of fine buildings pleasing to the eye. We are particularly blessed along Fishergate, where banks and building societies are plentiful. Two such buildings, standing either side of Lune Street, are the old Woolwich branch (now home to a furnishings retailer and an interior that displays signs of the art nouveau era) and the Royal Bank of Scotland building of 1899.

Preston had its share of sickness, death and poverty, which resulted in the provision of hospitals and a workhouse for those less fortunate. While criminal and military matters led to the emergence of courts, prisons and barracks, often of impressive designs.

In 1842 construction began on the Fulwood Barracks on the far side of what was then Preston Moor, and in 1865 digging began for the foundations of the Fulwood Workhouse on the same side of the Watling Street Road, which is itself Roman in origin. Those forest lands of Fulwood were populated with houses slowly – by 1853 there were only about a dozen occupied.

After its Preston Dispensary days the town developed a hospital at Deepdale, which became the Preston Royal Infirmary and served the town well before eventually closing its doors after the Royal Preston Hospital was opened by Princess Diana in 1983. The old PRI site retains some elegant old buildings that have been converted into flats on a housing and retail development, creating a shopping precinct called Deepdale Pavilions.

Pleasure and leisure may have been in short supply originally but theatres, and eventually cinemas, were provided to entertain. Leading the way was the old classic Theatre Royal on Fishergate, originally built in 1802; the George Inn Concert Hall then followed, along

with the Gaiety Theatre on Tithebarn Street in 1882; then came the Royal Hippodrome on Friargate, 1905; Empire Theatre on Church Street, 1911; and King's Palace on Tithebarn Street, 1913 – not that you will see any trace of them nowadays.

The glory days of the silver screen may have gone, although the modern multiscreen Odeon Cinema on Riversway attracts locals to the pictures. Hugh Rain, a pioneering film maker, converted the old Temperance Hall on North Road into a cinema in 1908. The first purpose-built cinema in town was the Palladium on Church Street, built in 1915. A good example of these palaces of pleasure is the old Savoy Cinema on Ashton Street, opened in 1921, where nowadays you can get your timber and doors. Great cinema auditoriums did follow, the last one being the ABC Cinema on Fishergate in 1959, but it lasted only until 1982. A few of these old buildings still remain about the city to remind us of the twice-nightly era. There is also the Preston Playhouse Theatre on Market Street West, opened in 1947 to provide drama.

The growth of civic life led to the construction of a number of fine structures and institutions, particularly around the Market Square, suitable for the genteel in society, alongside the common folk. Such buildings, erected in late Victorian or early Edwardian days, were quite outstanding in both their design and appearance and are a credit to their architects. The Harris Free Library, Museum & Art Gallery, the Miller Arcade, the Session House and the old Post Office building are still there in their magnificence to be enjoyed.

In later years the town hall and Guild Hall on Lancaster Road, the Cubic, the Preston Crown and Magistrates' Courts and the Preston Bus Station have been erected and are all distinctive in their design, creating a blend of modern and traditional architecture in our city centre.

A view from the top of Preston Bus Station looking towards Avenham.

Shopping arcades were a far-reaching thought when Nathaniel Miller drew up the plans for his development of Miller Arcade, yet nowadays such emporiums of shopping are commonplace. Supermarkets and superstores encircle our city, and in keeping with the retail demand Preston has developed accordingly. The St George's Shopping Centre, Friargate Shopping Centre, Guild Hall Arcade, St John's Shopping Centre, and the out of town Deepdale Retail Park and Capitol Centre in Walton-le–Dale are modern developments for the trendy shopper.

Despite the shopping centres there still are a number of distinctive buildings that are retail shops in the city: Waterstones on Fishergate, of 1859 origins, was once the flagship store of Edwin Henry Booth; the Next store, once Woolworths; and BHS and Marks & Spencer, which trade on opposite sides of Fishergate. Fishergate is more a place for cafés and coffee shops than public houses; Brucciani's, which opened in 1931, with its art deco fittings and fixtures, still leads the way amid the Costas and Starbucks of modern times.

We are fortunate in Preston to be blessed with public parks aplenty and these were developed from pasture land and meadow. The Moor Park, Avenham Park and Miller Park all had their roots during the troubled time of the cotton famine in the early 1860s, when cotton hands took up the spade, pick and shovel and helped to create the Victorian delights.

Moor Park has the Serpentine Lake and alongside its magnificent avenue of lime trees there are a row of schools, colleges and old mansions. Avenham Park delights us with its valley and such fascinating structures as the Belvedere and the Swiss Chalet, while Miller Park has a refreshing fountain, beautiful flower beds and a splendid terrace of steps leading to the much paraded Derby Walk.

Since then the Ashton, Haslam, Ribbleton (formerly Waverley) and Grange Park, having been added to the portfolio of green and pleasant places and the gardens of Winckley Square, are tended by Preston's Parks Department.

A view from St George's Shopping Centre.

The River Ribble still flows along the southern boundary of the city beneath the historical bridges and although it's no longer populated with sailing and rowing boats, it is a refreshing sight. Its course was diverted slightly in the late Victorian period to enable the magnificent engineering work to be undertaken for the creation of Preston Dock. Those toils led to a period of shipping days when great vessels came to town. The Port of Preston closed in 1981, but the legacy of that period is there for all to see in the area we now call Riversway. Some fine old warehouses were converted to apartment blocks; lots of houses, apartments and offices were built, along with restaurants and a cinema, and the old dock railway is now the Ribble Steam Railway where enthusiasts gather and watch the engines go by. The dock basin itself is packed with sailing vessels and canal barges and a route to the sea and the canal is open.

Gone are the days of swimming galas on the River Ribble, a dip in a mill lodge or the open-air swimming pools on Haslam, Ribbleton and Moor parks, or at Saul Street baths. Instead leisure centres at West View and Fulwood provide a chance to swim or indulge in other fitness activities. The cricketers of Preston Cricket Club still play at the West Cliff ground, where the pavilion is of great interest. It started as a wooden structure in 1862, was made of brick in 1878 and then enlarged in 1892. A stand was added in 1936 when Lancashire came to play. Preston North End FC have remained at their original Deepdale Enclosure and built a modern football stadium in recent years.

There is little doubt that the biggest influence on the city these days is the University Of Central Lancashire, particularly in the Fylde Road area of Preston. Their ever-expanding campus led to numerous new buildings and be they schools of learning or halls of residence, they have a modern look about them. Interwoven with the increased influx of students, a number of old public houses in the vicinity have been turned into apartments for students including the Watering Trough, Princess Alexandra, North Star, Hornby Castle and the Cottage.

Perhaps a person's most precious possession is their home, and Preston has certainly developed in this respect. The need of dwellings for those early cotton workers led to building of vast rows of terraces in Frenchwood, Deepdale, Ashton and Tulketh. Then in a twenty year spell between the two world wars the Preston Corporation alone built 2,600 dwellings; the first housing estates were built at Ribbleton and Holme Slack – neat red brick with slated roofs and gardens. The Callon estate was developed next, from there building progressed to Greenlands and then to Ribbleton Avenue, followed by Frenchwood. Still, the demand was great, so flats and houses also appeared on Inkerman Street, followed by Southern Parade.

By the mid-1950s plans were in place for a great slum clearance of properties; the building of council houses also continued at some pace. In 1957 a new project to build seven blocks of flats and maisonettes was progressing well in Samuel Street. By 1960 large areas of Avenham had become a vast slum clearance site and the old terraces were replaced by high-rise apartment blocks. Similar tall structures would soon be raised around the town. Rural areas were targeted by town planners and in 1964 some 200 acres of farmland in Ingol were earmarked for a new council estate containing 2,500 dwellings. Vast estates have followed with many created by private developers to accommodate a sprawling city; Preston's population in 2015 was 140,000, which highlights its growth.

The policy of building upwards in the town centre continued when it came to office space, with a development on Lancaster Road constructed in 1972 called Preston Office Centre. Office blocks would soon become commonplace.

In the pages that follow we visit some of the oldest, quaintest, tallest, smallest, busiest, boldest and the brashest buildings in the city. There is little point in dwelling on the buildings that have gone, their useful purpose over, but much better that we embrace those that remain from long ago, or have appeared on our streets in recent times.

Throughout the book there are references to the cost of buildings or structures at the time. To assist in calculating the values please consider the following Bank of England inflation figures: £1,000 in 1750 is thought to be worth £200,000 today; £10,000 in 1900 is thought to be worth £1.1 million today. So that would suggest that the £100,000 spent by Nathaniel Miller on building his Miller Arcade in 1899 would have set him back around £10 million today. While the £4,200 spent in 1779 building Walton Bridge would now mean a £660,000 spend. The Roman Catholic Church raised £8,000 to build St Ignatius in 1833, nowadays they would need £860,000. As for the Fulwood Workhouse costing £88,000 in 1865, that relates to a £10 million budget today. The cost of the Ritz Cinema on Church Street was £50,000 in 1938 which would cost £3 million today, while the sale of Edward Rodgett's (of Avenham Tower) collection of paintings at £7,837 would have netted him over £880,000 today. And apparently if you had deposited £1 in the Old Bank on Church Street in 1776, it would have been like investing £150 nowadays.

We must give great credit to those who toiled to build the structures that eventually became the City of Preston, whatever the cost. Little could the early nineteenth-century dwellers have imagined that the Preston of today would exist quite like it does.

The old and the new – the Guild Centre Tower.

The 50 Buildings

1. Nos 33 and 34 Market Place (1638)

A visit to Market Square begins this journey with a seventeenth-century link to the past. Up until the mid-nineteenth century the square was much different than today and included, on the southern side, in front of the old Moot or Town Hall, shops and houses that could be traced back to the 1620s.

The row of shops and restaurants today facing the Harris Library, Museum and Art Gallery across Market Square, collectively known as Cheapside, include some premises with a Market Place address. Among them is the gable-fronted shop of Thomas Yates Jeweller's, which is a half-timbered structure. It is believed to have been erected around 1638 and records show it was the residence of town surgeon Dr Wortton back in 1684.

Originally the timbered building extended to its left, but reconstruction in the twentieth century led to the emergence of two adjoining shops. Under their listed status the premises are described thus: 'originally a house, later two shops, timber framed, partly rendered, partly weather boarded with Welsh slate roof'. Internally, much timber framing has survived.

Back in 1948 No. 33 was home to Theakstons, a tobacconists who had Timpson's and the Benson Shoe Company as neighbours. Old customers of the shop recalled a statue of a monkey on the counter with a gas flame coming out of its mouth, enabling customers to light their cigarettes or cigars. In February 1933 the Kettering & Leicester Boot Company were pleased to announce the opening, after the modernisation of No. 34 Market Place, premises from which Josiah Green's shoe business had traded for over fifty-five years. By 1985 the

A Market Place reminder of the distant past.

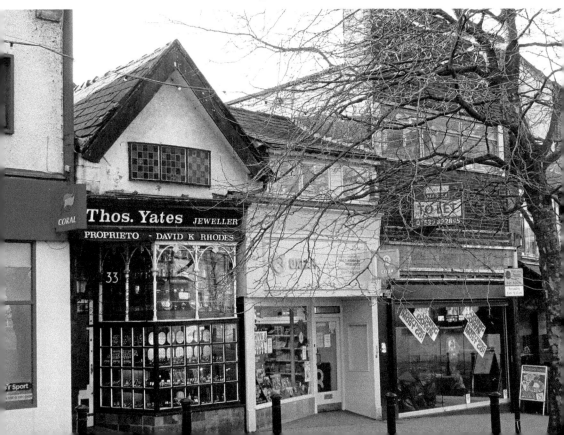

Thomas Yates business had moved to these premises from their once familiar address of No. 12 Friargate, where they had traded back in 1840. Thomas Yates was a nineteenth-century local watchmaker who earned a silver medal for his design of a DeadBeat Lever watch. Alongside the Yates shop, these days the old shoe shop is occupied by Oxfam and their charity workers.

2. Avenham Walk (1696)

According to the 'Order Book' of Preston Corporation it was stated in March 1696 that the ground at Avenham, known as the walk, be purchased and planted with trees and a gravel path should be created. The land had belonged to Alderman Lemon and he was paid the sum of £15 for it. The walks were largely extended in 1846. Previously, at the end of the walk there was a rough declivity to the river, where now there are flights of steps and terraces.

Upon his death in 1735, Doctor William Bushell, credited as the founder of the Bushell's Hospital at Goosnargh, was the owner of much property in Preston and the surrounding districts. A part of his estate was situated in the Avenham district in the as yet undeveloped Avenham area, and included Avenham House which at the time was let to Mr Henry Fleetwood. His land there comprised half of Avenham Walk along with what were known as the South Gardens and Higher and Lower Gardens, which are now the sites of Bushell Place, Porter Place, Lathom Street, Bairstow Street and Chaddock Street.

The marvellous views afforded from the Avenham Walk at the beginning of the nineteenth century were much appreciated although the Avenham Colonnade and Ribblesdale Place

Avenham Walk viewed from the Harris Institute steps. *Inset*: Avenham Walk, 1855.

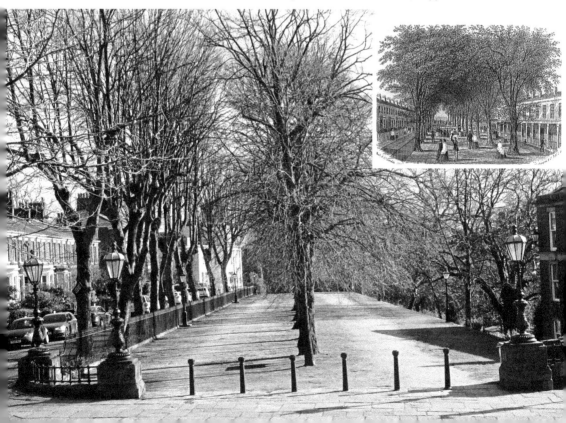

Avenham Walk leads to the Harris Institute building.

would soon be erected, as would Bushell Place, to partly obscure the view. A scribe in the *Preston Chronicle* in 1863 had this to say about Avenham Walk:

> The beautiful avenue of limes which adorn Avenham Walk have a fair claim to our veneration being some 160 years old. How many generations of Prestonians have enjoyed the beauties of Ribblesdale under their refreshing shade! How many have been carried thither in childhood, have gambolled there in youth, have whispered there, in manhood the tale of love, and have there felt a glow, in their declining years, through their aged limbs from a hot repose in the summer's sun! What a beautiful view the Walk commands! The Ribble flowing through the valley beneath, its waters apparently untainted during its course. Its surface on a summer's evening is studded with numerous pleasure boats. Below on the fields many a joyous group are playing merry games, their ringing shouts of laughter reaching Avenham Walk.

Avenham Colonnade is a terrace of six brick houses on a sandstone plinth with sandstone dressings and slate roofs. They are two storeys with basements, and each house has a two-bay front. Originally there was a row of stone pillars to the front of this terrace which formed a colonnade. Around 1860 the lower storeys were moved forward and the pillars discarded.

Bushell Place became an elegant terraced row of town houses from *c*. 1830 and is linked to nearby Porter Place, home to more listed buildings. The development of Ribblesdale Place was done gradually from around 1820, eventually creating a double row of properties either side of Avenham Lane: individually built premises, yet collectively almost as one, creating terraced rows.

In 1849, the graceful-looking stone building, the Mechanics Institute, which looks onto Avenham Walk, was completed at a cost of £6,000. It was the successor of an Institute for the Diffusion of Knowledge which opened in Cannon Street in 1828. The building is

of stone from the Longridge quarries, and is a combination of Greek and modern Italian architecture, having a commanding frontage around 60-feet wide. The building contains a spacious basement with two floors above. Thanks to the Harris trustees the building was extended on the north side in 1882 and became the Harris Institute. Unfortunately, the building, later known as the School Of Art, was recently allowed to go into private ownership and its future seems uncertain.

3. Unitarian Chapel, Percy Street (1716)

Almost hidden away among a modern apartment development is the shell of the former Unitarian, or Dissenting, Chapel. Anthony Hewitson in his book *Preston's Churches & Chapels* (1869), informed us that in 1716 a little building called the Presbyterian Chapel was erected for the Nonconformists of Preston on a piece of land near the bottom end on the north side of Church Street. This was the first Dissenting chapel raised in Preston, and in it the old Nonconformists, or Presbyterian, believers spent many a free and spiritually happy hour. Eventually the generality of the congregation developed their beliefs for Unitarianism and from that time onwards the chapel was held by those whom we term Unitarians.

By the mid-nineteenth century the chapel had been developed and was described as an old fashioned, homely-looking building, simple to a degree, prosaic, diminutive and snug. The body of the chapel was light and comfortable in appearance and accommodated around 200 people with a central aisle running directly up to the pulpit, flanked with a range of high old-fashioned pews.

Preston Corporation eventually bought the premises in 1973 from the tiny congregation who had moved to the Quaker Meeting House in St George's Road. Local campaigners fought for the building's preservation, citing the architectural and historical importance of it, and it became a listed building in May 1974.

The Unitarian Chapel and gate posts survive on Percy Street.

The building lay neglected for the next fourteen years and after vandalism struck demolition seemed likely, although plans were later made to turn it into an Ecumenical Centre for all faiths. A cost of upwards of £250,000 to restore the premises deterred those who campaigned. There was better news in May 1995 when work began to convert the run-down chapel into an apartment building of dwellings of various sizes; during this development the historic outer shell of the chapel was retained.

4. Arkwright House, Stoneygate (1728)

In 1728 the Corporation erected the building now known as Arkwright House for the headmaster of the Preston Grammar School to reside in. The building is in Georgian style and constructed in brick with a stuccoed façade and a slate roof. The house is three-storeys tall with cellars and an attic.

The building's name was given in recognition of the significant events that took place there in 1768 when the Revd Ellis Henry lived there and Richard Arkwright hired some rooms. Arkwright, one of Preston's most famous sons, and John Kay used the rooms to complete the final trials of their water frame which helped to revolutionise the cotton industry.

Arkwright House, nowadays cared for by Age Concern.

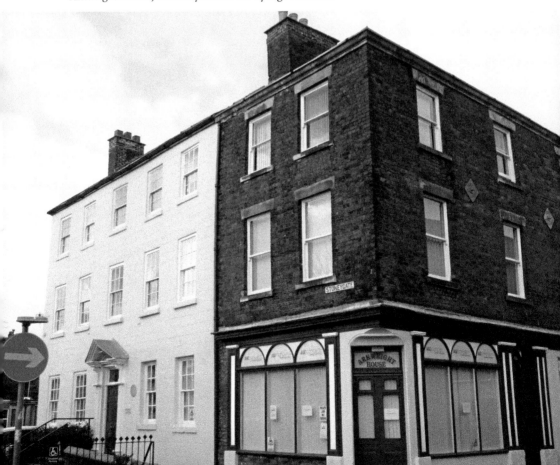

As a schoolmaster's residence it will always be remembered and associated with the Revd Robert Harris, who became headmaster of the Free Grammar School (situated at the bottom of Stoneygate at Syke Hill) in 1788 and held the post until 1835.

Eventually, it became a public house owned by Preston Corporation who sold it to Richard Threlfall Jr, a wine and spirit merchant, in around 1852. In 1892 it was made into a common lodging house after being bought by Caleb Margerison.

In the 1970s there was talk of pulling the house down such was its state of disrepair. Fortunately, a group calling themselves the Friends of Arkwright House rallied to the cause and raised a large proportion of the £120,000 needed to restore the premises and create offices. Princess Alexandra called to officially reopen the place in July 1980. Despite its restoration and its use as an educational centre, by July 1988 it was looking forlorn and neglected again: ground-floor windows were boarded up and squatters had to be evicted.

In December 1988 the charity Age Concern came to the rescue and it is now their headquarters. They have obviously taken care of the premises and its appearance is a great credit to their organisation.

5. The Old Bull, Church Street (1773)

Looking from Church Street at what are nowadays called The Old Bull and Harry's Bar, you could be forgiven for being unaware of this building's magnificent past. It was a place where the very best of society gathered and events took place on a grand scale. To earlier generations the building was known as the Bull & Royal Hotel, although a delve into the deepest archives suggest as long ago as the late seventeenth century what existed of it then was titled the White Bull.

The former Bull & Royal Hotel building still trading.

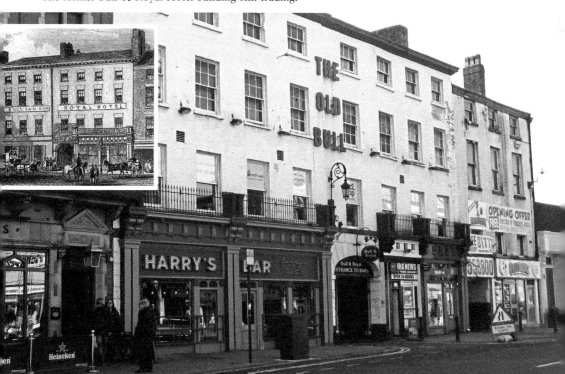

The inn was acquired by the Earl of Derby in 1773 and he arranged for extensive work to be done by the architect John Hird. This included the building of the much admired Derby Assembly Rooms, which is lit by Venetian windows and contains a minstrel's gallery and elaborate plaster work.

The Bull Hotel became a popular venue, with fashionable balls held periodically and the best of entertainment provided. The Bull has been the stage of many rejoicings: distinguished visitors, including Charles Dickens, have been entertained there; dinners and feasts have taken place and there has been much jubilation of a political, municipal and social character. Many a politician has delivered speeches from its balcony to the accompaniment of cheers or catcalls. Royalty have also been known to patronise the place and in 1913 George V and Queen Mary dined in the Derby Room while visiting the town.

It was revealed in August 1975, as the new Crest Hotel on the ringway was about to open, that the Bull & Royal would no longer function as a hotel, although the public bars would remain open.

The £1 million Crest Hotel is an imposing structure situated on the ringway and is now trading as a Holiday Inn. Alongside it is the former Visionhire eight-storey high office block which opened in November 1977. It served as a computer and administration centre for owners Granada for over a decade, but was left empty until 1994 when it was announced that Conlon Construction were about to revamp the building. It is now known as New City House.

Church Street, originally called Churchgate, once home to numerous inns and taverns still retains other significant public houses from those stagecoach days. The Blue Bell can lay claim to being the oldest of them. The prefix 'Ye Olde' was used at times and it is recorded that as long ago as 1716 the court leet records show that the landlady Widow Hall was fined 40s for keeping a disorderly house. A recent external renovation, which brings the original brickwork into view, gives it an even more authentic look as an inn steeped in history.

The Old Dog Inn was established on its present site by the 1730s and down the archway to the side were extensive stables where up to sixty horses could be accommodated. The Widow Walmsley was an early licensee and her involvement with Martha Thompson – the town's first Methodist – led to it being recognised as the birthplace of the Methodists in Preston.

From its opening in 1809 the Red Lion was part of the coaching scene, as the harnesses jangled and the iron-shod hooves rattled on the cobbled streets of Preston. In 1824 the landlord William Cotton gladly welcomed the passengers on the Invincible stagecoach which daily halted at 8.45 a.m. on its way to Carlisle. There was a chance for the weary passengers who had travelled all night by way of Manchester, Bolton and Chorley to stretch their legs and have a tasty breakfast.

The Bears Paw dates back to the early nineteenth century and it was the meeting place of the Preston Landed Interest Club. Drinking gin and puffing on their church warden pipes, the members were said to be a narrow, materialistic crowd obsessed with property and money matters. It had become the Grapes Hotel by 1880, a title it relinquished in 1975 when the inn was redeveloped and emerged as a railway themed pub called the North Western. By the 1990s it was the Bears Paw once more, and then flirted with other titles such as 12 Bar and Pogue Mahone before once again revealing it really is the Bears Paw.

The public house named Yates these days is another shrouded in antiquity. When opened in 1808 it was the Grey Horse and had taken the name Addison's Wine Lodge well before landlady Mary Addison, of the Yates family, took over in 1859. The original premises had a thatched roof and in those coaching days of 1824 a daily stagecoach to Liverpool and back for 7s was on offer.

The Blue Bell, the Bears Paw, the Old Dog, the Yates and the Red Lion may display few clues to their past, yet are linked together in antiquity. The first three nowadays display their pub name from the coaching days while the Red Lion is now trading as Popworld, although it retains the figure of a rampant lion above the door.

6. Old Black Bull, No. 35 Friargate, (1776)

Friargate has, since medieval times, been one of the main streets of Preston and so, quite naturally, it has had numerous public houses along its stretch of highway. Incredibly by 1844, according to Whittle's list of inns and taverns, it had sixteen such places devoted to the supplying of alcoholic beverages. Five of those survive today.

The Old Black Bull survived the coming of the Preston Ringway which split Friargate in two. It is an eighteenth-century inn with claims to have existed since 1776. It was rebuilt

The Black Bull on Friargate, an old survivor.

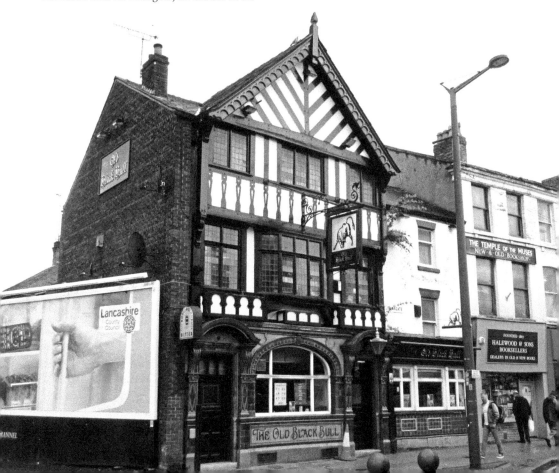

in the early Edwardian period to the design of Garlick & Sykes in the mock-Tudor style. It is three-storeys high with a cellar, and among its features are a green-tiled lower frontage. Its increased popularity led in recent times to an extension by conversion of the adjoining premises, once home to the Dallas Inman Art Gallery.

The other inns of great longevity along Friargate are the Dog & Partridge, Lamb & Packet, Sun Inn and the Black Horse. Some sources suggest that the Dog & Partridge existed as long ago as 1772. A refurbishment in 2015 led to the grand reopening of a public house which was often associated with the gathering of leather-clad motorbike enthusiasts in the 1980s.

The Lamb & Packet derives its name from the lamb on Preston's coat of arms and the Packet Boat service to Kendal which ran along the once nearby Lancaster Canal. This inn has its origins back in the early days of the canal when many a traveller would call for refreshment.

The Sun Inn can lay claim to an existence before 1810. It is recorded that during that year workmen, while digging at the rear of the place, unearthed a cartload of bones including a skeleton of a gigantic man, described back then as 6 feet 7 inches tall.

The Black Horse, on the corner of Orchard Street, can be traced back to at least 1796, although for a time in the nineteenth century it was known as the Black Horse & Rainbow. It was completely rebuilt in 1898 and is well worth a visit, if only to view its well-preserved interior with a magnificent bar counter complete with fine art nouveau stained-glass panels.

Indeed, all of these historical inns retain architectural features that define their antiquity. At the present time work is going on to restore the former Plough Inn which closed over ninety years ago and is situated next to Roper Hall. Painstaking restoration work has uncovered links to the early 1700s.

7. Bridges across the River Ribble (1779)

Up until 1755 the only bridge that crossed the River Ribble in Preston was a five-arched one into Walton-le-Dale, constructed some 130 years earlier. Eventually, it was deemed unsafe and in 1779 work started a short distance up the river on the now familiar three-arched Walton Bridge which cost £4,200 in construction. Not much further up the river from Walton-le-Dale is the old Tram Bridge. It was originally a wooden structure, built to connect the canal at Walton Summit with the Lancaster Canal at Preston by tramway. Those were the days when the Lancaster Canal flowed from just beyond the Corn Exchange in Lune Street northwards. The bridge was used until 1859 to carry a tramway that conveyed coal between the two canals and the wagons were hauled up the steep Avenham incline by steam power from an engine house.

The original rickety, wooden structure of 1802 construction was given a structural overhaul in 1902, and in 1936 it needed running repairs after flood water debris damaged supports. During the Second World War the timber decking was removed to thwart any potential German invasion advances. In 1966 it was lovingly restored by Preston Corporation with concrete replacing the worn timbers.

The coming of the railways brought the necessity for three more bridges over the River Ribble. The East Lancashire Railway Bridge joined the landscape in 1846 with its three main arches spanning the river. With a public footpath running alongside the track, it was

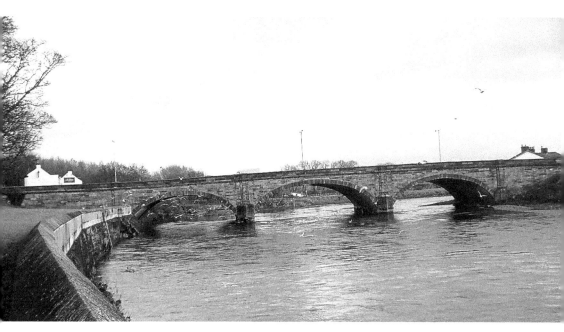

The river crossing into Walton-le-Dale since 1779.

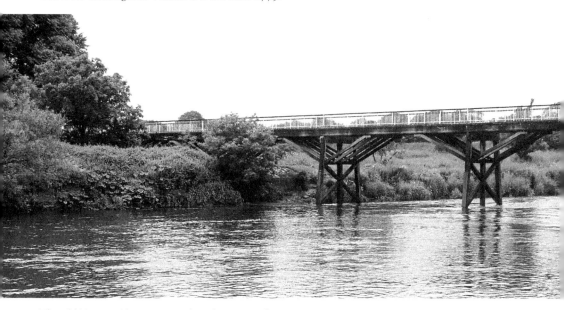

The old Tram Bridge, renovated in the twentieth century.

a welcome addition at the time. Once the trains stopped passing over the bridge it was neglected for a while, but nowadays it is a convenient pedestrian and cycleway, although it comes to an abrupt halt with fencing barring access to the Fishergate Shopping Centre. The North Union Railway Bridge that crosses the river a little closer to Penwortham was opened in 1838 with its five stone arches; a large influx of Irish immigrants worked on

its construction. Such was the increase in railway traffic that it was widened in 1879 and 1904 – the stone pillars and steel girder frame reveal that fact. To this day it is a vital rail crossing into Preston's Central Station.

Not much further along the river was the old West Lancashire Railway bridge of an iron girder structure, which was completed in 1882 and went through to the old railway station at the bottom of Fishergate Hill. The substantial piers of stone still remain as a reminder of that old rail route, which ceased operation in 1964.

Up until the mid-eighteenth century, should you have wished to cross into Penwortham then you had the option of crossing either by ferry or by one of the two fords. The Penwortham Bridge was erected in 1755 but fell down due to poor foundations, being eventually rebuilt in 1759 with its five arches of stone. It may have been narrow, high-backed and inconvenient, but from a distance it is quite picturesque and these days it's a delightful thoroughfare for pedestrians and cyclists alike.

8. HMP Preston, Ribbleton Lane (1789)

Preston Prison is one of the city's most historical structures and is thought of as a place of foreboding that we like to pass quickly by, yet just prior to the Second World War it seemed to be in its final days.

It was opened in 1789 at the eastern end of Church Street and was named the House of Correction. It was the brainchild of the celebrated philanthropist and prison reformer John Howard. Howard travelled the world studying different forms of punishment and the Preston project was to be among his last before his death in 1790. The House of Correction was where thieves, beggars and other petty criminals would be put to hard labour in an attempt to reform their criminal tendencies. The buildings, being for the reception of criminals, were surrounded by a three-tier-high boundary wall with a governor's residence, a courthouse, and wings containing ground and attic cells, weaving shops, a hospital, and a chapel. It was an impressive complex and in later decades extra wings were added with additional cells.

Nowadays, HMP Preston is a Category B prison.

By 1819 the prison was governed by William Liddell who had two turnkeys and two taskmasters under him. Together, these five had to control 350 prisoners who were employed from dawn to dusk, mainly weaving and cotton picking with the goods produced being sold to Horrockses, a local textile company. Two prisoners shared a cell, which were furnished with straw mattresses and bed boards. The prisoners' diet consisted of bread, potatoes, oatmeal, cheese and stew.

The new structure had replaced an earlier House of Correction which had stood to the west of Friargate and opened in 1619. Howard had visited that place in 1777 and described it as a 'dreadful, dirty and dilapidated prison'.

The expected demolition of Preston Prison in 1938 never occurred. It had previously closed in 1931 due to a shortage of prisoners. Prior to the Second World War it became a Civil Defence store and eventually a naval prison. It was due to close again at the end of the war, but an increase in crime led to its reopening as a civil prison.

By 1978, the prison, by then exclusively populated by males, was the residence of 574 convicts. The inmates were a mixture of petty thieves, burglars, swindlers and murderers, and included lifers. By 1996 a long needed refurbishment was underway with prisoners 'slopping out' for the last time. Prisoners were moved from the prison's old C wing to A wing, where the cells were fitted with their own toilets at a cost to the taxpayer of £2.2 million. The population fluctuated between 300 and 450.

These days it is a Category B local prison accepting all adult male prisoners from Crown Courts and Magistrates' Courts serving Lancashire & Cumbria. Cell occupancy is double and an operational capacity of over 740 is possible.

Alongside the HMP Preston on Stanley Street is the old courthouse. This was operational by 1829, replacing the original courthouse within the prison walls which was deemed too small. The original structure, costing £10,000, was designed by Thomas Rickman; in 1861 considerable additions to the building were made, including an extra courtroom. For a period of 75 years the building served as the place for the Preston Quarter Sessions to be held, along with the County Court proceedings from 1847. When the new Sessions House was built on Harris Street its days of dispensing justice were over. The building, between 1911 and 1958, was the home of the Royal Artillery. It later became the local home of motor vehicle taxing and registration.

In 1983 it became the County & Regimental Museum and in 1997 it became the Museum of Lancashire. A year later, thanks to Heritage Funding of £189,000, the nearby derelict church and grounds of St Mary's were added to the portfolio after restoration work.

What followed were years of pleasure in a place where you can wander, wonder and admire the memorabilia, artwork, trinkets and treasures, and even sit on an old school bench with slate boards and inkwells. This enthralling museum is enchanting and educational with exhibitions, displays and entertainment within.

9. St Wilfred's Church, Chapel St (1793)

Work began in 1792 on this Catholic chapel after purchasing the land from a timber merchant named Thomas Woodcock. St Wilfred's Church was first opened in June 1793 having cost £3,500, it was then rebuilt and enlarged in 1843. The purchase of Mr Talbot's

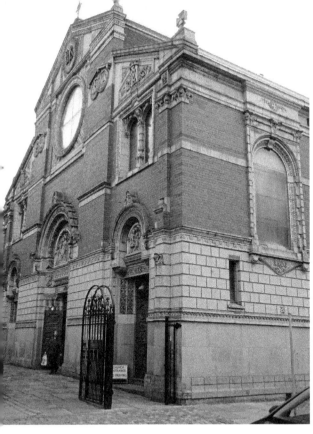

The much-admired St Wilfred's Church.

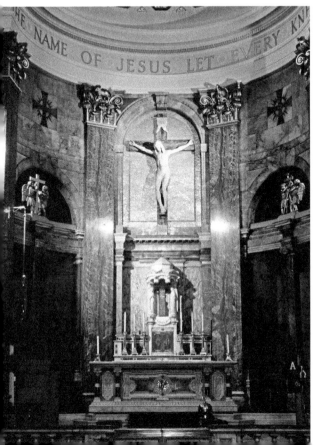

A stunning interior greets visitors.

stables at the east side for £400 enabled the building of a vestry and Lady chapel and a lengthening of the church. Forty years later it was closed again for reconstruction, reopening in April 1880. Further renovations followed in 1892 and a baptistery was erected in 1901.

The building is in the architectural style of an Italian basilica. It is built in brick with terracotta cladding and dressings, and has a slate roof. It is complete with nave, baptistery, chapels and an apse at the eastern end. Large Corinthian columns add to the internal splendour.

The priest whose name is mostly associated with the development of the parish is the Revd Father Joseph Dunn. A Jesuit priest, he was affectionately known as 'Daddy Dunn' and arrived in Preston in 1776. Besides his endeavours in church building he was instrumental in the erection of the Catholic school in nearby Fox Street, behind which was the old walled graveyard for local Roman Catholics. When Father Dunn died he left all of his money to the school, which helped to pay off their £600 debt. He was also a pioneering figure in the formation of the Preston Gas Company. He died suddenly in November 1827, aged eighty-one, and is buried beneath the sanctuary of St Wilfred's Church.

Like many buildings of great age, the church has needed plenty of conservation work and improvements over the decades: mosaic panels, marbled walls, ornate doors, crucifixes, tabernacle alterations, alter changes, organ overhaul, roof repairs, inner porch alterations and exterior sandblasted; all done to ensure the continued beautifying of this church. With its basilican interior, it is a welcoming place for those who wish to kneel and pray in quiet solitude. Although its inner parish is only populated by 500 people these days it regularly attracts more than 400 worshippers to Sunday Mass.

10. Cardinal Newman College, Lark Hill (1797)

Although this sixth-form college only dates back to 1978, the history belonging to the site commences in the latter years of the eighteenth century. It was the place where Samuel Horrocks had his splendid mansion built after purchasing the land known as Albin Heys in 1797. Although busy building cotton factories in the neighbourhood, he found time to employ Messrs Wren and Corry to build his mansion home called Lark Hill.

The house was an elegant and substantial brick building with the entrance through an impressive gateway off King Street (now Manchester Road). This mansion had a number of elegant apartments on the ground floor, stained-glass windows galore, a dining room with a semi-circular bay, a first-floor drawing room and numerous bedrooms, dressing rooms and bathrooms all adding to the magnificence of the place. Kitchens, a butler's pantry and housekeepers' quarters were included within the structure, along with servants' quarters in the attic, a bakery in the basement and wine cellars and coal cellars below stairs.

Numerous outbuildings added to the splendour, with a 30-feet long heated conservatory, and those necessities of life: a brewhouse, a dairy, a wash house and a laundry.

Within Samuel Horrocks' great property portfolio was also Albyn Bank House, built of brick with stone bay windows in 1801 and used by members of his family and later by other colleagues in the cotton trade. From around 1860 it was the vicarage of St Saviour's, a church that stood on Manchester Road.

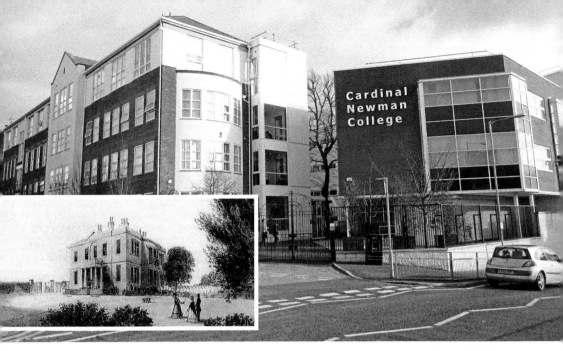

The Cardinal Newman College campus has absorbed the mansion. *Inset*: Lark Hill House, home for the Horrockses.

Samuel Horrocks loved his Lark Hill mansion which he shared with his wife Alice and their eight children. Sadly, his beloved wife died at Lark Hill in July 1804, aged thirty-eight. The eight children she left behind, none older than fourteen, were then cared for by family and servants. In his later years, with the business of the cotton firm in the hands of others, including his only son Samuel, he kept a full staff of gardeners and servants to maintain the estate. When he died at the age of seventy-six in early March 1842 his son took up residence at Lark Hill.

Unfortunately, Samuel Horrocks Jr lived only until the age of forty-nine, dying in February 1846. In truth, his widow Eliza cared little for Lark Hill and she only lived there occasionally after his death, although a full staff of servants was kept on. Eventually, in 1855 she had a deed drawn up and signed by all the beneficiaries to dispose of the estate. Lark Hill came up for sale in 1859 and a committee who had been responsible for building St Augustine's Church raised the £4,500 necessary to buy it at auction.

This led to the arrival of Sisters of the Faithful Companions of Jesus in 1861, and within a year, a day and boarding school was established. The nuns were welcomed in the town and the Lark Hill convent was described thus a decade later:

The grounds are a lovely picture, delightfully formed, and most snugly set. The convent is a large, clean, airy establishment. The entrance hall is handsome; some of the apartments are choicely furnished, the walls being decorated with pictures and tapestry made by either the nuns or their pupils. The convent includes apartments for the reception of visitors, a small chapel, with deeply-toned light, and exquisitely arranged; dining rooms, sitting rooms, two or three school rooms, lavatories, sculleries, dormitories, and a gigantic kitchen, reminding one of olden houses wherein were vast open fire-places. Altogether, 22 nuns live at this convent and they lead quiet, industrious lives and appear to be contented. Besides teaching the 33 resident girl pupils they teach at the neighbouring schools.

From 1919 it was a direct grant school known as Lark Hill Convent Grammar School, with nuns and lay teachers providing education. It was a convent that flourished, with over 500 girls being taught there in 1961 when the centenary of the convent was celebrated; physics, chemistry, biology and domestic science were on the agenda with numerous class rooms having been added.

In 1978 the Lark Hill Sixth Form merged with the sixth forms of the Winckley Square Convent and the Preston Catholic College and became Cardinal Newman College. A £35 million remodelling of Cardinal Newman College was announced in October 2007 with plans approved for three, four and five-storey extensions replacing the old east and west wings. Much of the old mansion was swept away in the progressive plans.

If you visit the area nowadays it is apparent that a number of new buildings have emerged, including the newly built St Cecilia and St Francis buildings. Also, the acquisition of the St Augustine's Centre, which was made into a leisure and sports centre (at a cost of £5 million) after the demolition of the main body of the church in 2004, adds to the campus feel of the district.

11. Winckley Square (1799)

Preston is blessed with a number of public parks just a short distance from the city centre, one such place being Winckley Square. This area owes its existence to William Cross, an attorney who completed his legal studies in London in the late eighteenth century. Inspired by the magnificent inner-city parks and squares there, he dreamed of creating something similar in Preston. He cast his eye over the land known as Town End Field at the rear of St Wilfred's Church, and after approaching his fellow attorney Thomas Winckley with his scheme he negotiated to buy the land from him.

This led to Mr Cross erecting the first house in the square in 1799, though it was called Winckley Place at first and the entrance in Winckley Street. It is a brick house on a stone plinth with sandstone dressings. It is two-storeys high with cellars and an attic. The gabled end on Winckley Square has five bays. When Mr Cross decided to take up residence at Red Scar, barrister John Addison moved in. The Addison family connection with this house ended in the early 1850s when John Addison and his elder brother Thomas Batty built No. 23 Winckley Square.

The second house, built directly opposite across Winckley Street with its main entrance on the square, was erected for Nicholas Grimshaw (seven times mayor of Preston) who had a lucrative legal practice. A brick house with sandstone dressings, it stands three-storeys high with a basement and a five-bay frontage. The doorway is approached up three steps and has Tuscan columns on either side with a semi-circular fan light.

Within a space of five years further building had continued along this northern face of Winckley Square, including the mansion at No. 1 Chapel Street. Other properties began to appear along the other sides and by mid-century it was the residence of many of Preston's prominent citizens. In truth, few histories of Preston are written without mention of previous residents, such as: Edward Hermon, MP for Preston; Edward Gorst; Thomas Miller; John Swainson; William Ainsworth and John Humber of cotton fame; Edith Rigby, the suffragette; the knighted Doctor Robert Charles Brown; Samuel Leach, businessman and banker; and the Revd Carus Wilson, church builder.

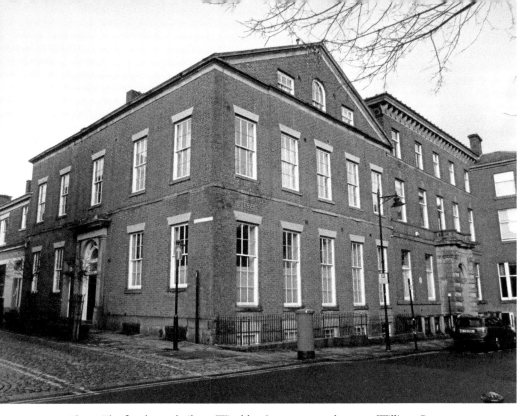

Above: The first house built on Winckley Square – once home to William Cross.

Below: The second house built on Winckley Square – where Nicholas Grimshaw dwelt.

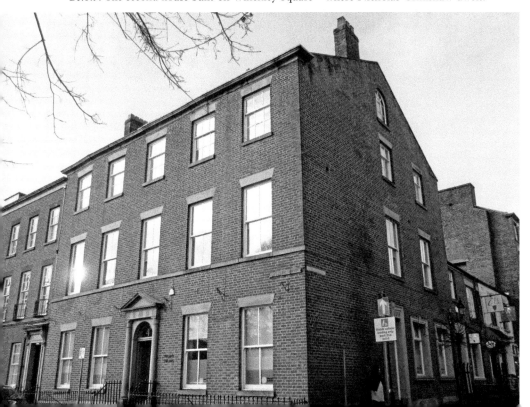

It also became a place of great institutions, such as the Winckley Club, the Literary & Philosophical Society, the Catholic Grammar School, and the Convent of the Holy Child Jesus.

Yet a scribe of 1860 had this to say while visiting the square, 'The garden part is large and sloping to a hollow, in which vegetables are cultivated and clothes hung out to dry. In truth it must be an eyesore to the occupiers of the handsome house and institutions that surround it'.

By the early 1930s it was no longer an exclusive residence of wealthy and fashionable citizens, and many of the old residences were occupied by offices of lawyers, accountants, land agents, insurance companies and commerce.

The actual garden area was becoming neglected and the concept of having private garden areas for the residents was seen as outdated. In 1950, historian John H. Spencer suggested that the gardens looked quite pitiful and forgotten. A year later a number of agreements were signed between Preston Borough Council and landowners for maintenance of the gardens in local authority hands. It was subsequently declared a public open space and the Parks Department set to work turning the tangle of undergrowth and decaying trees into pleasant land.

In more recent times, Winckley Square has come to public focus with work continually being done to keep the gardens fit for those who like to stroll there. As recent as 2013, it was announced that £1 million had been secured from Heritage Lottery Funding to restore a number of the Georgian buildings. A number of them, including the former home of Sir Charles Brown, who lived at No. 27, and No. 28, once the home of Edith Rigby, are looking in need of tender care.

Winckley Square gardens, now a public space.

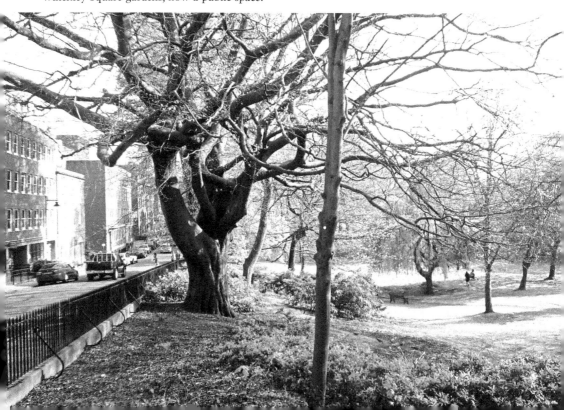

12. Ashton House, Ashton Park (1810)

Ashton House dates back to 1810 and was constructed amid a sprawling estate by Thomas Starkie Shuttleworth. It was built mainly in sandstone with the rear walls of brick and was enlarged and redesigned in the 1850s. Unfortunately, Shuttleworth died in August 1819, aged forty-five, leaving his wife and nine children behind.

Local banker James Pedder bought the estate in 1820 and the Pedder family resided there. Being the founding family of the Old Bank in Church Street they were much respected in the town. Eventually, Alderman Edward Pedder took control of the bank his grandfather started; there was much distress in March 1861 when he died suddenly at his Ashton House home. His death led to a rush by depositors, eager to withdraw their savings. The collapse of the bank was inevitable although, to his credit, one of his brothers, Henry Newsham Pedder, attempted to rectify matters. His efforts led to a payment of 17s 6d to the £1 for the investors. The house and estate then had to be sold to satisfy the creditors and the Pedder banking days were over.

The estate was purchased by Edmund Robert Harris and, along with his brother Thomas, he spent his later years there, although he preferred to live at Whinfield House on the corner of the estate which overlooked the River Ribble.

Those were the days of travel by horse and carriage; on Pedders Lane the former coach house and stables (known as Ashton Lodge), part of the Pedder estate and built in around 1851, still exist as a reminder of those times.

Upon his death Edmund Robert Harris bequeathed the estate to Queen Anne's Bounty, a charity that funded the poorer clergy. Later tenants included the Talbot Clifton family and Colonel Goodair, cotton manufacturer. In residence at Ashton House in 1915 was Frank Calvert, the managing director of a cotton mill in Walton-le-Dale. In September of that year he visited Scotland on an angling trip and was accidentally drowned. The estate was purchased by the English Electric c. 1920 and they used it as a social club and sporting venue.

Ashton House, once home to the Pedder family.

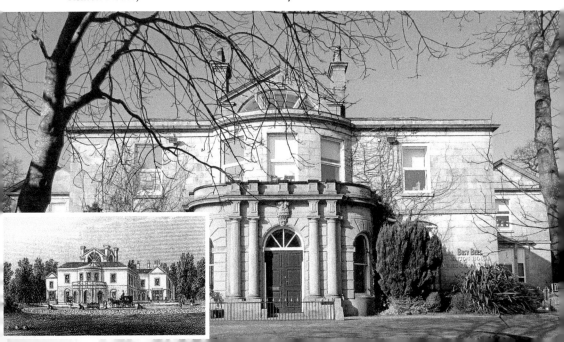

In June 1936 the Preston Corporation bought the estate for £27,000, obtaining a mansion, two bowling greens, six tennis courts, and football and cricket fields extending over 83 acres. By April 1937 the Parks Deptment were busy working on the grounds – Ashton Park days were soon to come.

The park remains a welcome part of Preston's green and pleasant lands and Ashton House has had a number of occupants. These days it is used as a child care nursery school called Busy Bees.

13. Corn Exchange, Public Hall, Lune Street (1824)

The original building, designed by William Corey in a Georgian style, was erected in 1824 at a cost of £11,000 by the Preston Corporation. Being 230-feet long with a frontage of 95 feet, the inner-court area was open to the sky. Within a few years it was hosting the annual Bachelors' Ball on St Valentine's Day, with provisions made for the arrival of horse-drawn carriages along Lune Street. It was a place where ladies and gentlemen would meet, yet by day all manner of markets were held.

In 1853 a glass roof was added that had been designed by Philip Park, mayor of Preston 1862–63. The area thus became available for large public meetings, fairs, markets, concerts and balls in all weathers.

The Corn Exchange – at the front is a statue to remind us of the tragic Lune Street riot of August 1842. *Inset*: A 1973 event in the Public Hall.

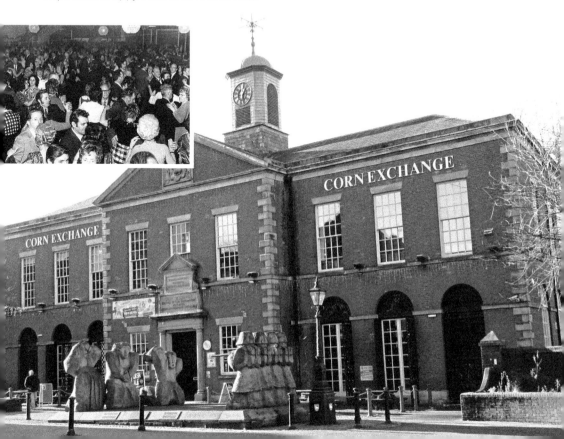

Further improvements began in 1881 and were designed and carried out by Mr B. Sykes at a cost of £16,000. The area was rearranged, centrally heightened and galleried to transform it into a public hall. At the time it became the largest hall in Lancashire, occupying 14,076 square feet and capable of accommodating upwards of 3,500 people. It was the perfect setting for the guild celebrations of September 1882 and from then on became known as Public Hall.

Generations of Preston folk have fond memories of Public Hall which proved to be a place of great entertainment: dance bands, singers and orchestras all performed here and lots of folk danced the night away. Hospitality was afforded to such musical greats as Franz Liszt, Fritz Kreisier and The Beatles.

With the imminent arrival of the Guild Hall its days were numbered and it closed in 1972. But when it became apparent the new Guild Hall would not be ready on time, it was given a lick of paint and played host to the ancient Preston Guild Court and a host of entertainers. The doors were eventually closed in March 1973 after an evening of nostalgia with the Joe Loss Orchestra playing Auld Lang Syne.

It then stood empty and neglected until 1990 when to facilitate the progress of the ring road it was knocked down, leaving only its front entrance and foyer. An extension was added to the rear and it was then opened as a public house. What remains of the original building is the frontage, which consists of a three-bay gabled entrance and three-bay flanking wings.

14. St Ignatius Church and Square (1836)

In 1833 it was estimated that out of Preston's 33,000 population, close to 9,000 were of the Catholic faith. With only the chapels of St Wilfrid's and St Mary's, another church was needed urgently. The proposed site was the Causeway Meadow, on the east side of North Road, on what we now call Meadow Street.

The story of the church began back in late May 1833 when the first stone of the edifice was laid. It would become the third church in Preston where priests of the Jesuit order laboured. It opened in early May 1836 and the first parish priest in charge of St Ignatius was Father Francis West, a Jesuit missionary who was pleased to have a congregation that numbered 4,000 souls.

The building was described as being in the English perpendicular Gothic style and it was designed by Mr J. J. Scholes of London. With a square tower and an ornate spire that reached up to 114 feet, topped with a cross 5-feet tall, it was a striking addition to the skyline – it possessed the first spire attached to any church in Preston. The cost of the church was £8,000 and those who attended the opening service had to pay up to 4s for admission.

What would follow in the parish in the years ahead were events such as the cotton famine, when soup kitchens saved many from starvation; the days of ragged schools, with barefoot boys and urchins; the church bazaars; the field days; the processions; the pomp and pageantry; and the school's sporting achievements on the playing fields.

Further improvements were made to the church in 1886 with many internal enhancements taking place, then in 1912 the Lady chapel and baptistery were built. The most poignant addition to the church surroundings came within ten more years: a war memorial made of Portland stone was erected in memory of the 228 men of the parish who lost their lives in the First World War.

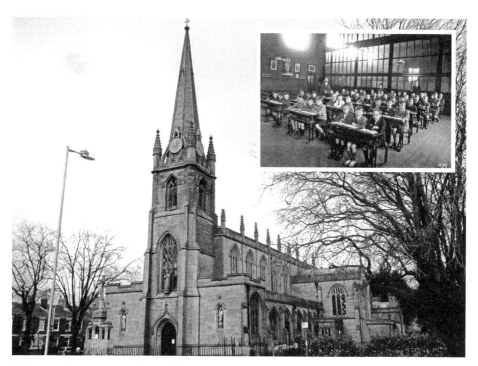

St Ignatius Church was welcomed by 4,000 parishioners. *Inset*: St Ignatius Boys' School – Class of 1924.

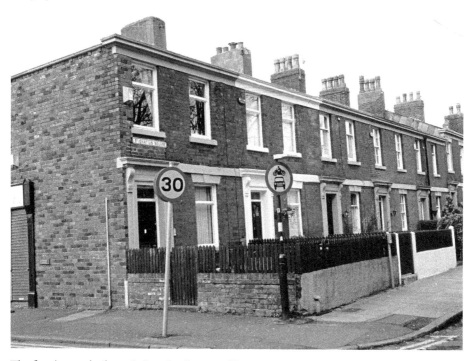

The first houses built on St Ignatius Square – Nos 1–5.

By 1840 the first houses were being built on the left-hand side of St Ignatius Square, with a terrace comprising Nos 1–5 and each property having two storeys and a cellar. They were constructed of red brick with sandstone dressings and slate roofs. The construction of Nos 35–40 on the opposite side of the square soon followed.

Unfortunately, the parishioners were downhearted in November 2014 when Mass was said for the final time prior to a merger with English Martyrs Church on Garstang Road, a reflection of the dwindling attendances and shortage of priests. The usual 140-strong congregation was doubled for the final farewell.

Controversy followed in early 2015 when it was announced that the church was to reopen after the Bishop of Lancaster offered it to the Indian faithful Syro-Malabar Catholics. With over 100 Syro-Malabar families in Preston, the new parish priest Father Matthew Jacob Choorapoikayil expressed his delight at the group having their first church in England.

15. Stephenson Terrace, Deepdale Road (1847)

On the east side of Deepdale Road, opposite the Deepdale Enclosure, built between 1847 and 1850, stands a fine line of town houses. The stone terrace was erected by contractor George Mould and named after the celebrated railway engineer George Stephenson. By then, Stephenson had the construction of the Preston and Longridge railway tunnel in hand, which is now known as Miley Tunnel and runs under the west side of the town – from the

Stephenson Terrace, built from stone brought from Longridge.

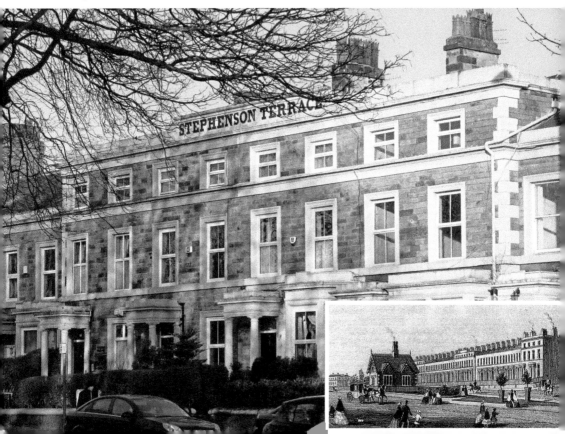

Deepdale terminus to Maudland. The fact that the railway terminated originally at the rear of Stephenson Terrace was a contributing factor in the choice of name, which is displayed in the stonework in the centre of the terrace.

The terrace consists of houses with front, walled gardens. They are two-storeys high with cellars and attics at the centre and the end properties, which add to the attractiveness; all of the doorways in the terrace have porches with Tuscan columns and pilasters.

The houses were occupied in the early days by people of notability, be they vicars, doctors, politicians or public servants (such as the Chief Constable of Preston, James Dunn). To the rear of the terrace was the railway terminal building and also the once familiar coal yards.

Across from the terrace there still remains the triangular and cultivated grassy area known as the Deepdale Enclosure. Two centuries ago the area was known as the Washing Moor, where laundresses could be seen daily scrubbing clothes and hanging them out to dry.

They are no longer the town houses of the gentry, many nowadays are surgeries, offices and business premises. These days when the converted offices come onto the property market, prices up to £200,000 are quoted.

16. Avenham Tower and Bank Parade (1847)

The inset image from 1855 shows the splendour of this development at the end of Avenham Walk. Avenham Tower was built as a block of three houses, each being: three-storeys high,

Avenham Tower; now apartments it was formerly home to the rich and famous.

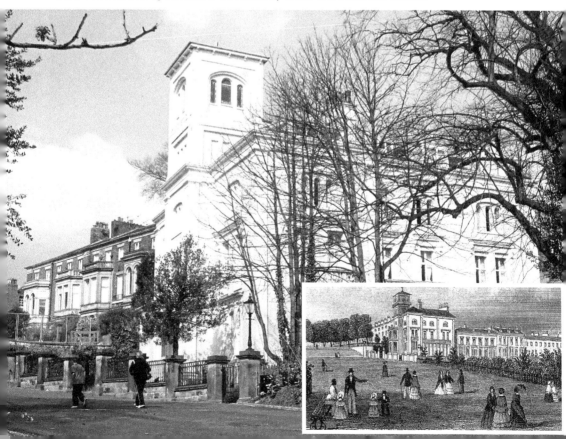

with cellars, attics and a five-storey tower with two square stages above the cornice. Its construction was intended to give an appearance of a single mansion overlooking the Avenham Valley. These days it has been converted into numerous self-contained apartments.

The owner of Avenham Tower was Richard Threlfall of Hollowforth, mayor of Preston in 1855 and the founder of the Threlfall & Co., wine and spirits merchants in Preston. Among the earliest residents of Avenham Tower were local builder James Walker and his family. Around that time he employed up to twenty men and boys in the building trade. A neighbour from the mid-1850s was Edward Rodgett, a magistrate who was also a dealer in art. In May 1859 a sale of his choice collection of English pictures and drawings was held at Messrs Christie & Manson. The 101 lots realised the sum of £7,837 and included *The Swing* by F. Goodall which sold for £766 and *The Poacher's Bothy* by Sir Edwin Landseer which fetched £735. A later neighbour of the Walkers was cotton spinner William Pollard. Perhaps the most famous of the residents of Avenham Tower was Edwin Henry Booth, founder of the grocery and tea business that grew into the Booths supermarket chain of today. He spent his latter years living there and when he died in January 1899, aged seventy, he left an estate valued at almost £70,000.

Bank Parade became an exclusive row of terraced properties of their own distinctive design. A feature of this development was the terraced gardens at their front, which in the early days were tended by the residents. Like Avenham Tower, it was blessed in those Victorian days with residents who were notable in Preston's society.

Bank Parade was a fashionable terrace row in the nineteenth century.

The first doorway on Bank Parade is the side entrance to Avenham Tower and is known as Avenham Lodge. The terrace that follows began in the mid-1850s with the building of Nos 14, 13 and 12 – three sandstone houses, two-storeys high with cellars, attics and bay fronts. In fact the terrace was developed either side of No. 9 Bank Parade, which had, since 1832, been the home of John James Myres, who was a surveyor by profession and was involved in the planning of the railways into Preston. He was twice chosen as mayor of Preston, firstly in 1868 and then again in 1873. Members of the Myres family remained at the house after his death in 1881.

At No. 13, from 1856 until his death, lived Joseph Livesey, who signed the famous Temperance Pledge in 1832 and began a movement admired throughout the land. A cheese merchant, newspaper proprietor and a much loved man, he died in September 1884 in his ninety-first year.

Viewing Bank Parade today, it is a row of properties of which many have been converted to apartments and a number of them have been neglected. Likewise, the terraced gardens have grown into a wilderness of weeds and brambles.

17. Fulwood Barracks, Watling Street Road (1848)

The preparatory work for the Fulwood Barracks commenced in July 1842. The land occupied by the barracks, barrack yards, and grounds included over 28 acres. The site on which they were erected was once a royal forest and included a portion of the old racecourse, around 1 ¼ miles from the town. The contractors for the erection were Messrs Bellhouse of Manchester. The stone used in all the buildings was obtained from the delph at Longridge, taking advantage of the Preston–Longridge railway for transporting the stone. It was fully completed in June 1848 and the cost of the works was £137,000. It was reckoned that over 350 builders laboured for over five years to bring the project to completion.

Internally, the buildings were arranged around two large parade grounds – one for infantry and one for cavalry. The officers had their own private apartments and the soldiers were housed in dormitories. There were guardhouses, officers' quarters, stables, barns, hospitals and even prison cells to cater for military needs.

The battalions of the 60th Rifles and the 81st Regiment were an early arrival at Fulwood Barracks. From those days, generations of soldiers gathered at Preston prior to involvement in military conflicts worldwide. The name of the Loyal North Lancashire Regiment is written frequently in the barracks' history and acts of bravery and gallantry have been commonplace. Of course regiments have amalgamated and changed names down the years, but their collective identity and history is not forgotten.

There was good news for Fulwood Barracks in March 2013, when it was announced that despite cuts in the defence budget the Army HQ North West would remain in the city, with up to £10 million being spent on regional developments. With 450 soldiers based in the city they could expect to see 200 more soldiers arriving, many of the Three Medical Regiment included.

If you should wish to delve into the history of Fulwood Barracks there is a splendid military museum within it, including the history of the Queen's Lancashire Regiment and the days of the Loyals and their military might.

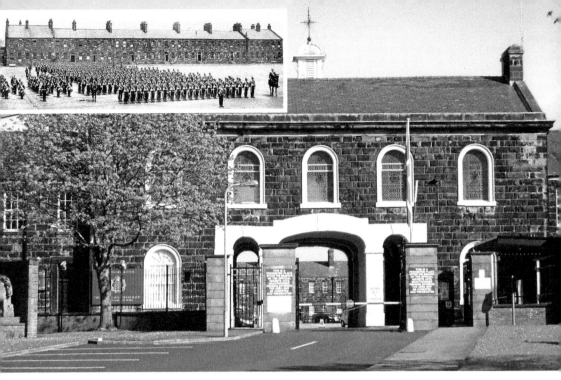

Fulwood Barracks. *Inset*: On parade in 1897, the Loyal North Lancashire Regiment.

18. St Walburge's Church and Spire (1854)

St Walburge's Church is steeped in the history of Preston. Its origins lie in the Jesuit legend of St Walburge's oil, which reputedly seeped from the marble of a shrine dedicated to Walburge, the daughter of a West Saxon king.

Back in 1844, Alice Holderness, housemaid at St Wilfred's Presbytery in Preston, suffered a fall and was left bedridden with a suspected broken kneecap. Despite medical help the injured knee would not heal. The Revd Father Norris, who was then at St Wilfred's, decided to apply St Walburge's oil to the injury. The oil was procured and Father Norris dipped a pen into it and placed a droplet upon the injured joint. According to Alice's sister, 'the bones immediately snapped together and she was perfectly cured, having no longer the slightest weakness in the broken limb'.

Miracle or not, the priests at St Wilfred's certainly believed in the cure and they decided to campaign for a church to be built in honour of St Walburge. The foundation stone was laid on Whit Monday in 1850, and early in August 1854 the church opened with a grand ceremony attended by the bishop of Liverpool.

Father Thomas Weston, who was also stationed at St Wilfred's, proved to be the leading light in the construction of the church, which was designed by Joseph Hansom, the architect of Birmingham Town Hall and, more famously, inventor of the Hansom cab.

Built in an early, decorated Gothic style of architecture, the new church was without doubt a striking structure. At the eastern end a seven light stained-glass window, flanked by a pair of light windows, made for an imposing countenance, while an artfully coloured circular window at the western end, along with other lesser lights dotted around, added to the magnificence of the building. The roof was also a wonder to behold: supported by eleven huge Gothic fashioned timbers, with stained panelled timbers above.

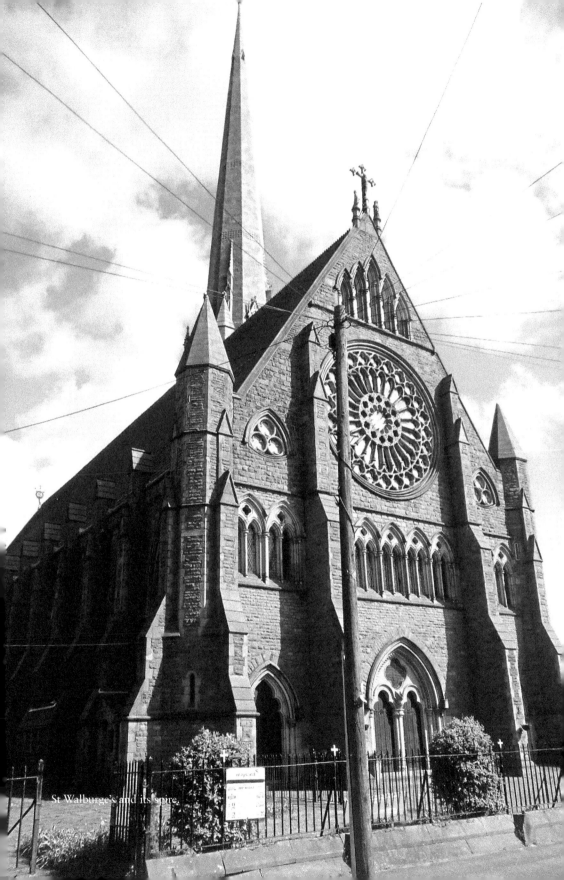

St Walburge's and its spire.

Despite the grand opening, however, it would be some years before the famous spire was completed. A slow and painstaking task, the work was eventually finished in September 1866. The last stone was laid and the weathercock put in position atop the wrought-iron cross by a daring mason named Thomas Holmes. A great crowd gathered to see the crowning glory and besides receiving pints of beer galore from the admirers, when he descended he received a £10 reward from the building committee.

From that date on, neither Prestonians nor visitors have been able to miss the graceful 306-feet tall limestone spire, which elegantly dominates the skyline from points all over the city.

In recent times as the Roman Catholic congregation has declined, there were doubts about the future of the iconic church building. However, in September 2014 it was announced that the Institute of Christ the King Sovereign Priest had secured an agreement with the diocese of Lancaster to ensure the church remained open to worshippers. The aim being to hold church services entirely in Latin in accordance with Tridentine Mass traditions.

19. Minster St John's and Chapel of St George (1855)

In June 2003 a new chapter began in the history of Preston's parish church when it was unveiled as England's newest minster. The interior had been redesigned with a new heating system and roof. Many of the familiar pews had been replaced by chairs so the church could host concerts, conferences and workshops.

The site has been occupied by a church building since AD 670 and carried the names of St Theobald's and St Wilfred's before being dedicated to St John the Evangelist.

Back in April 1853 the last service was held in the old building, which was been erected in 1770 with a tower added in 1816 and a chancel added a year later. A portion of the roof had been deemed unsafe and plans were drawn up by Mr Shellard of Manchester for a new building. His brief as architect was to design a church in the flowing, decorated English style, consisting of a nave and two side aisles, a tower and lofty spire at the west end, and a chancel at the east end. The porch, with a handsome pointed doorway, formed the principal entrance into the church.

In mid-June 1855, it was opened for divine service led by the Revd Canon John Owen Parr, who was vicar of Preston from 1840–77. According to observers at the time the appearance of the church, with its lofty arched roof, stately pillars, and numerous stained-glass windows, it formed a striking contrast to the barn-like edifice that it had replaced.

The minster is very much at the heart of the city and down the decades it has been a focal point of Preston life with civic processions, civic celebrations and civic funerals adding to its historical importance to the city.

The minster nowadays encompasses the historical St George's Chapel on Lune Street, both under the management of the Vicar of Preston, Timothy Lipscomb. Built in 1725, the chapel was expanded in 1799, it was encased in stone in 1843–44, a chancel was added by Edmund Sharpe in 1848, and the church was remodelled in 1884 at a cost of £6,000. It is built in sandstone with a slate roof, and is Romanesque in style. The church consists of a nave, aisles, transepts, a chancel and a porch with a tower. Among those buried here are: Samuel Horrocks, a former MP for Preston and cotton manufacturer; and Dr Richard

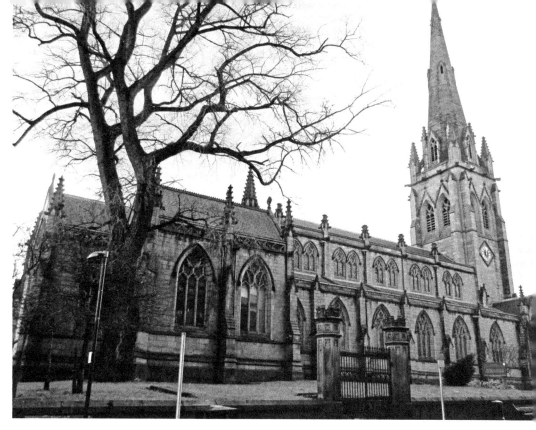

Above: The Minster opened in 1855 on a church site from AD 670.

Below: St George's Chapel, originally built in 1725.

Shepherd, twice mayor of Preston, who donated his extensive library of books to the town. The person who will be forever associated with this chapel is the Revd Robert Harris, the incumbent of St George's for sixty-four years. On Christmas Day 1861 in the middle of the cotton famine, he gave a passionate sermon for parishioners to rally against the bitter strife. It was to be the final address from the aged patriarch who died just days later, aged ninety-eight.

20. No. 40 Fishergate, Sainsbury's Local, Former Preston Bank (1856)

Sainsbury's, who nowadays have a large supermarket in Deepdale on the site of the old Deepdale Isolation Hospital, invested in a local convenience store on Fishergate in 2014. The fact that it was in the premises once known as the Preston Bank was seen as a blessing by those concerned about the future of one of Preston's old and cherished bank buildings.

The building was designed by local architect J. H. Park in the form of an Italian palazzo. It is in sandstone with a slate roof, has three storeys and a five-bay front. There are five arches on the ground floor housing doorways and windows. It was opened in October 1856.

Due to financial difficulties, in July 1866 this bank suspended payment, but with careful management and patient depositors it resumed business in late August. One name forever associated with this bank is that of Gerald Thomas Tully, who in 1883 absconded after an audit discovered he had taken £10,000 out of the accounts. This deputy manager was traced to New York, but attempts to extradite him failed. He died in Chicago in 1888.

Flanked by banks, the new Sainsbury's Local. *Inset*: Preston Bank *c.* 1857.

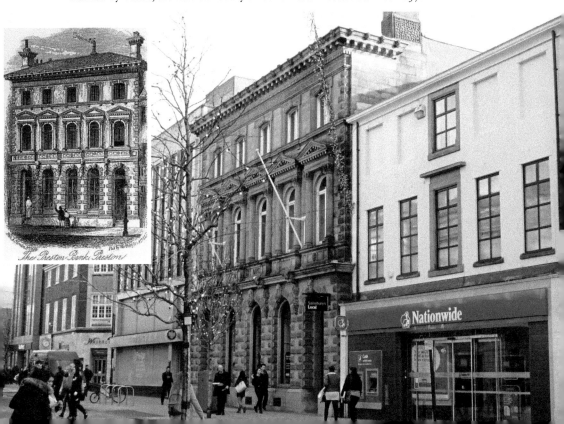

The Preston Banking Company had been formed in 1844 by a group of local corn and cotton merchants and it developed into one of the largest provincial companies in England. It became part of the London & Midland Bank in 1894.

As familiar as the Midland Bank for later generations of Preston folk, it ended its banking days as the HSBC bank. The building had been empty for nearly seven years amid fears for its future.

21. Fishergate Baptist Church (1858)

Back in July 1857, the foundation stone of the Fishergate Baptist Church was laid. This church was to replace a chapel in Leeming Street (now Manchester Road). The building design cost £5,000 and was entrusted to a rising young architect, James Hibbert.

The finished building, capable of accommodating 550 people, was described in the press as follows: 'as chaste and elegant a temple of religion as is to be found within the precincts of our town'.

Such a grand building earned praise from far afield, with the famous architect Sir Gilbert Scott describing the rose window overlooking Fishergate as one of the finest examples of its kind that he had ever seen. Within three years of the opening the four-sided clock was placed in the 110-feet tall tower, paid for by public subscription with the Preston Corporation agreeing to maintain it.

Since that time it has been an iconic clock tower on our landscape and in its early days it was lit by gas, provided for free by the Preston Gas Company. Many a rail traveller has set their watch by it, and for decades it has been the first thing that often caught the eye as visitors walked up Fishergate from the railway station.

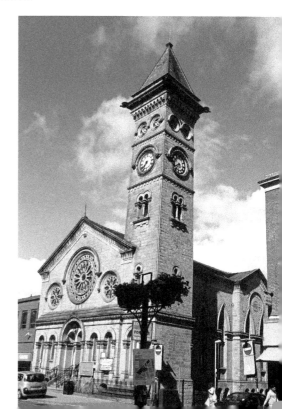

Fishergate Baptist Church – truly iconic.

When historian Anthony Hewitson visited the chapel in 1869, the congregation numbered over 200 and he described it as the centre of gravity for the more refined and fashionable worshippers.

One notable visitor in Victorian days was author John Ruskin; he thought so highly of the church that whenever he passed through Preston he would spend some time in meditation within its walls.

In 1958 the church celebrated its centenary with the Revd Kenneth Jarvis at the helm. On that occasion the five surviving pastors were invited to attend: the Revds Garside, Morris, Maxwell and Clark, along with Sister Ivy Manning.

Back in 1991 the church building was threatened when an IRA bomb was detonated behind the RAF Recruitment Office next door.

In later years it became a haven for the homeless people glad of a warming bowl of soup; church and youth groups also met within. It is a Grade II-listed building and a prominent feature on Fishergate, although it now displays a 'For Sale' sign let's hope it receives the care it deserves.

22. Fulwood Workhouse, Watling Street Road (1868)

In late July 1865 the foundation stone of the Fulwood Workhouse was laid by Thomas Batty Addison on the north side of Watling Street Road. The architect was Leigh Hall of Bolton and when the workhouse was opened in late December 1868 the cost of the development, including the furnishings and a hospital at the rear, was close to £88,000.

The building, comprised of three storeys, with cellars, has an almost palatial external appearance and was built in the Italian style of architecture. Its wide, sweeping façade, has a centrally surmounted clock tower and cupola. Originally the spacious interior had quarters for general inmates; school and work rooms; a dining hall to cater for 670 people at one sitting; chapel facilities for Protestants and Roman Catholics; and rooms for the master, matron and other staff members.

The old Fulwood Workhouse building, still in use as a teaching and business centre.

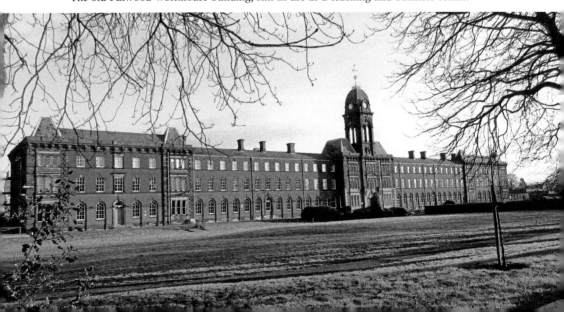

Within the following fifteen years an infectious hospital, casual wards and a rear wing were also added, bringing the total spend to £103,000. The workhouse with its associated buildings stands on 12 acres of land. At the rear a garden and meadow was put to good use by the able-bodied inmates who cultivated enough produce to feed the inmates, with other crops such as hay also being sold.

The number of residents fluctuated but 1,500 could be accommodated if necessary. Able-bodied men were normally employed in stone breaking and land tilling, while those less able were expected to pick oakum. Able-bodied women were expected to do the washing and other household chores. Boys were taught tailoring, shoemaking or baking, and the girls taught to knit, sew and clean.

In the more enlightened times of the twentieth century, the role of the workhouse for paupers diminished and the Fulwood site gradually developed into what we once knew as Sharoe Green Hospital. With the coming of the National Health Service in 1948 the workhouse was renamed the Civic Hostel and various buildings were added or converted at the rear. It became the place where the maternity unit would deliver 1,500 babies a year, including myself, under the watchful eye of senior consultant Howie Todd. By 1973 it had new wards for gynaecology, plastic surgery, coronary care, orthopaedics as well as a suite of operating theatres. It was regarded as a caring hospital in 1980, with facilities including 500 hospital beds. Things move swiftly though in the medical world and the dawn of the new millennium brought news of its closure with transfer to the Royal Preston Hospital of patients and nurses alike. By September 2004 it was 'farewell Sharoe Green Hospital'.

23. Covered Markets and Market Hall (1875)

The land where the Covered Market was built was 'Colley's Gardens' – a patch of land inviting development. The very fine Covered Market occupies an area that is 355-feet long and 101-feet wide. The roof is a remarkable specimen of the engineering skills of Edward Garlick, Mayor of Preston 1882–83; it has no internal supports, the outer pillars alone maintain its position.

The contract for its creation was entered into by Joseph Clayton of the Soho Foundry in February 1870 for £6,070, but when he had constructed around one-fourth of the roof a severe storm destroyed it compltely in early August and he gave up the contract, declaring that no roof made on that principle would stand rough weather.

Messrs Bennett & Co. of Birmingham then undertook the work for £9,000, but they also gave it up alleging a similar objection. Its construction was then undertaken by Messrs Allsup & Sons of Preston in May 1872 and they completed it at a cost of £9,126 in 1875.

The second phase of the Covered Market, covering the area used as a later fish market, was completed by the 1920s. That particular plot had only become a market area in January 1914, being originally used by general market traders who kept an eye on the weather. Fish from Fleetwood would arrive by train early each morning at Butler Street and the fishmongers would flock to collect the hake, cod, plaice, and gurnet and pack it in ice for taking to their market stalls. Certainly the fish market thrived under the canopy with a tasty kipper, a pickled herring or a smoked mackerel often being the housewife's choice.

The Market Hall was opened in 1972. The construction led to the demolition of the properties on Liverpool Street which included the old Gothic style Orchard Methodist

The fishmongers and butchers are inside the Market Hall these days. *Inset*: The outdoor Covered Market.

Chapel, closed in 1954. The designers had taken advantage of a 14-feet fall from Lancaster Road to Starch House Square, enabling the hall to be designed on two levels. Late October was the last time that shoppers could wander through the familiar fruit, veg and fish stalls on the covered markets. The stallholders were all set to move into the spanking new market hall – just a potato throw away.

These days the Covered Markets are in the process of being renovated, with an overall design incorporating the existing canopies and the Market Hall under threat of demolition. Meanwhile the hardy traders and stallholders carry on offering their traditional goods to local folk. Bric-a-brac stalls may have given way to car boot stalls, but there is still plenty on offer.

24. Deepdale Stadium, Preston North End (1875)

Preston North End began their days by playing cricket, and later rugby, playing their fixtures on Ashton Marsh, then later on the Moor before leasing a field at Deepdale in 1875. However, it was the game of association football that eventually took a grip after their first trial game in October 1878. By the autumn of 1880 the club had abandoned the oval ball and joined the Lancashire Association Football Union. What followed was the growth of the football club into the team that became known as The Invincibles after winning the first Football League Championship and the 1888/89 FA Cup.

By 1890 what was known as the Deepdale Enclosure had a large and a small stand on the west side with a press box in between. On the north and east sides were uncovered

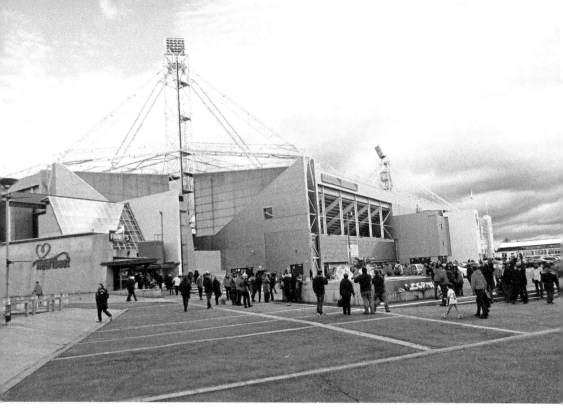

Match day at the modern stadium, completed in 2008.

terraces. In January 1906 the club opened a new West Stand with a terraced paddock and seating for over 2,500. In 1921 a large Kop at the Fulwood end was opened at a cost of £19,000. By the mid-1930s they had a cover over the Town End terraces, and a new Pavilion Stand had been built. It cost £9,000 and became the HQ of the place with offices, a boardroom and dressing rooms. A couple of years later it was extended and all was set for the record-breaking attendance of 42,684 versus Arsenal in April 1938 (the year PNE last won the FA Cup).

Leaping forward to October 1994, when Baxi took over the club, which had been as low as second bottom of the old Fourth Division, plans were drawn up to modernise the old stadium. Chairman Bryan Gray recruited lifelong fan and graphic designer Ben Casey to draw up plans. The first phase of the development got under way in May 1995 with contractors Birse and the demolition of the decaying West Stand. Opening in March 1996 the new Sir Tom Finney Stand incorporated the National Football Museum and had a seating capacity for almost 8,000. The next stage of the development began in 1997 when the old Spion Kop stand was replaced by the Bill Shankly Kop which recognised the former PNE FA Cup winner of 1938.

By October 2001 the old Town End had gone and the Alan Kelly Stand named after the former PNE goalkeeper was opened. The summer of 2007 saw the old Pavilion Stand knocked down and a new Invincibles Pavilion Stand was opened in August 2008. Thus the four sides were complete in the all-seater stadium, which had a capacity of over 23,000.

The footballer regarded as Preston North End's greatest ever player is Sir Tom Finney. The Deepdale legend, a local lad, made 433 league appearances and scored 187 goals for PNE. An England international, he played seventy-six times for his country, scoring thirty

goals. He retired in 1960 and remained connected to the club for the rest of his life. A water feature sculpture of Finney called 'The Splash' was erected in 2004 outside Deepdale, capturing a moment in time versus Chelsea at Stamford Bridge on a waterlogged pitch. He died in February 2014 aged ninety-one.

25. Central Railway Station, Fishergate (1880)

Erected by Messrs Cooper and Tullis and formally opened in July 1880, Preston Central Railway station remains at the heart of the railway system.

Great was the progress in the mid-nineteenth century with regards to the mode of railway travelling, both in regard to the speed and accommodation provided for travellers. Since the year 1838 lines leading in all directions have spread out from Preston, making it one of the centres of railway communication. The first railway in these parts was the one connecting Preston from its Butler Street station with Wigan, which was opened on the last day of October in 1838.

At the beginning of May 1840 the Preston to Longridge Railway was opened with its terminus initially behind Stephenson Terrace in Deepdale, prior to a tunnel being constructed under Preston to take the line to Maudland. In June of the same year the town was connected with Lancaster, followed weeks later by the opening of the Preston & Wyre Railway between Preston and Fleetwood which involved the construction of the viaduct at the bottom of Tulketh Brow.

By February 1846 Preston and Lytham were united, and soon afterwards railway communication was established with Blackpool and Blackburn. In the same year the Ribble Branch Railway, connecting the Preston Quays with the Butler Street Railway Station, was completed. By this time the first railway to Wigan had led to a connection with Bolton via the Euxton Junction and ultimately a link with Manchester.

Add the Preston–Liverpool line in 1849 and a connection with Southport via Burscough Junction six years later, and the folk of Preston were almost spoilt for choice with seaside, country and city now just a train journey away. In later years more direct routes to Blackpool and Southport would also follow – all of which led to the necessity for a central railway station.

The new station, costing £250,000, was described at the time as one of the finest in existence. It was built between Butler Street and Charles Street with its front facing Fishergate and included a much needed bridge on Fishergate. It incorporated six lines running through the station onto the platforms and on the western side, four sets of rails for goods trains and shunting purposes. Booking offices, luggage departments, waiting rooms, refreshment rooms, stationmaster and staff quarters all added to its splendour. Most significant of all though was an underground passage leading to all the passenger platforms to end the need for commuters to cross the rails – a practice that had led to too many deaths to mention.

It was seen as a blessing to have such a station and it has served Preston well. There have been upgrades and renovations over the years, but the original design remains very much intact. The steam engines made way for the diesel engines, and electrification of the rails followed. Recent upgrade work was carried out in the booking area of the station and the general appearance remains 'quite brilliant and beautiful' as historian Anthony Hewitson stated in 1883.

Preston Station, standing the test of time since Victorian times.

A Virgin train arrives at Preston station

On Corporation Street stands a small timber-framed building which has strong links to the Preston railway workers. It owes its origins to the Railway Mission, dating back to 1885 when Mrs Brown (the widow of Canon Brown, the former vicar of Holy Trinity Church) conducted Sunday Services within the buildings on the central platform of the station. The railwaymen, through the necessity of working on the Sabbath, were thus given the opportunity of hearing the gospel.

The present day timber-framed building in Corporation Street was opened in December 1900, costing £670. Nowadays this church building carries the title Preston City Mission and holds its ground alongside the newly built and imposing Preston Premier Inn.

26. County Hall, Fishergate Hill (1882)

In 1882 Preston could reflect on the town's increased importance within Lancashire following the erection of the new County Hall and Offices on Fishergate. The premises were to be used for the Court of Annual General Sessions and for the County Constabulary. The style of architecture was that of the latter period of Elizabeth I and James I. The architect was Mr Henry Littler of Manchester, and the cost of the structure was around £58,000, inclusive of the site. The elevation was of pressed red brick, with stone string courses, cornice, mullions, and jambs, gables, and shields on which were carved the Royal and Duchy Arms.

The whole presented a frontage to Fishergate of 178 feet, and to Pitt Street a frontage of 152 feet. In the rear of the building was a parade ground for the constabulary, an occasional courthouse and cells for temporary prisoners. The whole of the building was erected by Mr John Walmsley of Preston.

County Hall viewed from the Fishergate Bridge.

Fast forward to May 1934 and a meeting of Lancashire County Council was held in a new County Hall, following extension work that had begun four years earlier with the excavations for foundations and basement and the demolition of a street of cottage property. The U-shaped block has a frontage of 160 feet to Pitt Street and is five-storeys tall with a basement.

Once again, this demonstrates local brickwork with lavish stone dressings in harmony with the original structure. It had cost £150,000 including furnishings, and was an opportunity to bring many of the county services together. The new County Hall itself was at the core of the new structure, with a council chamber 64 feet by 54 feet lit by eight large arched windows. With accommodation for 134 aldermen and councillors, along with a public gallery, it was an impressive arena.

These days County Hall remains very much at the centre of county administration and further extensions have followed on the old Christ Church site. While part of the 1836 church frontage remains, additional conference rooms and a car park have also been added.

27. Park Hotel, Miller Park (1882)

On the height where the Park Hotel now stands once stood an ornamental cottage visible through a wealth of trees. During Preston Guild Week in 1882, this fine, new hotel overlooking Miller Park was opened. Recognising the need for hotel accommodation near to the railway station, it was built jointly by the London & North Western and Lancashire & Yorkshire railway companies. It is of Elizabethan design and the architect was Arnold Mitchell of Oldham, whose design was selected in an open competition and earned him £200.

The Park Hotel overlooking Miller Park.

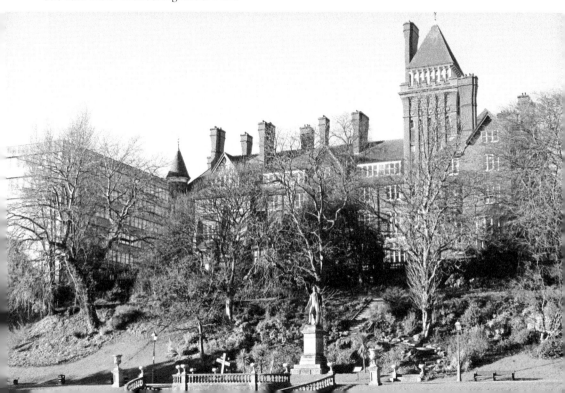

The general structure was built of red Ruabon brick with a roof of red tile by contractors Messrs R. Neill & Son of Manchester. It has a frontage to the south of 174 feet, and to the west of 152 feet; the tower, which adds to the buildings picturesque appearance, is almost 114-feet tall. Internally it lacked for little, having drawing, dining, breakfast, commercial, writing, billiard and smoking rooms. Many of the bedrooms were large and sumptuous with baths and toilets aplenty. The ground floor was central heated but the upper rooms had coal fires for heating.

The cost of the hotel, exclusive of furniture, was some £40,000 and an approach to the hotel for visitors was constructed from the station platform along an elevated covered way. It was certainly a popular hotel in its heyday and had many distinguished visitors who were breaking their journey from London to Glasgow with a night's rest.

After the coming of British Rail, the British Transport Commission sold the hotel in 1950 to Lancashire County Council for £85,000 and they converted it to offices. Unfortunately, not long after the purchase of the hotel Lancashire County Council saw fit to erect a tower block of offices alongside. This brought an outcry from locals who regarded it as a blot on the landscape and to this day it is spoken of in derisory terms.

28. Preston Docks, Riversway (1892)

From the earliest of times the River Ribble has been used for trade and transport by Preston folk. This is illustrated by the remains of a Bronze Age canoe and other artefacts on display in the Harris Museum, which were uncovered during the Preston Dock construction in

Preston Docks – a place for leisure and pleasure.

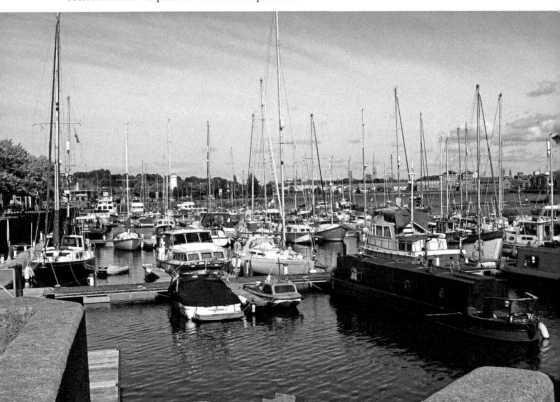

The old Preston Dock offices on Watery Lane.

the 1880s. Various Ribble navigation companies have taken care of the vital waterway since 1806. The Victoria Quays, where brisk trade developed, made it apparent that a dock basin would be beneficial. In 1883 the Ribble Navigation & Preston Dock Act passed the undertaking to Preston Corporation to oversee the construction of the Preston Dock.

The official opening took place on the last Saturday of June 1892 by Prince Albert, Duke of Edinburgh, second son of Queen Victoria. At the time the basin was the largest single dock in Europe, being 3,000 feet-long by 600-feet wide.

Busy, bustling Preston Dock was the cry in October 1958 when almost 1.5 miles of quays were occupied by the biggest array of shipping the dock had seen in years. Nearly 17,000 tons of shipping, including nine foreign deep-water vessels were in town, unloading wood pulp, timber, hardboard, vehicles, fruit, paper, china clay, oil and general cargo.

The Port of Preston was prospering and by the year 1961 traffic revenue topped the £1 million mark. The introduction of a new transport container service between Londonderry and Preston was further proof of good days ahead. Sadly things did not quite progress as hoped in the decades ahead, with dredging of the waterway channel being a never-ending problem. Profit margins were forever small and eventually, as more and more transporting of goods went onto the expanding motorway system, the business declined leading to the closure of the docks in 1981.

Eventually what we now know as Riversway was developed, creating an area surrounding the dock basin devoted to housing, offices and retail business. A multiscreen cinema, two public houses, restaurants and a Morrisons supermarket store opened in July 1987, and a basin full of sailing vessels and canal boats all part of the legacy of the pioneering dock developers of late Victorian days.

One other reminder of the days of the dockers is the old Dock Offices on Watery Lane, situated opposite the old dock entrance. The building opened officially in February 1936, but now carries advertising hoardings talking of telesales opportunities. The building, of what we may now call art deco design, created much interest. It is a two-storey building

with a sharp rectangular outline, square clock tower, and a flat roof. In the main hall are two stained-glass windows: one depicting an old sailing ship and the other a modern steamer at the quayside unloading a cargo of wood pulp, which was handled in bulk at Preston Dock. The contract for the new building was given to Mr A. Threlfall of Leyland, whose tender was for £21,617.

29. Harris Library, Museum & Art Gallery, Market Square (1893)

To someone such as myself this building is a time traveller's delight, for within its archives is such historical information that can transport you to times gone by. The formal opening of the building took place on 26 October 1893 by the Earl and Countess of Derby, accompanied by Alderman Edelston, the Mayor of Preston, and all the town's dignitaries, watched by a great crowd on the Market Place.

It was a couple of years before the building was fully operational, and it had taken a decade to construct under the guidance of the architect, James Hibbert. The building was funded at the bequest of Edmund Robert Harris, who died in 1877; it was built in sandstone of Greek Revival style. At the front, facing the Market Place, is a giant portico of fluted Ionic columns flanked by recessed bays with giant pilasters. Altogether it cost £122,000 to build and was admired by all.

The Harris, a place of splendour viewed from the Market Square.

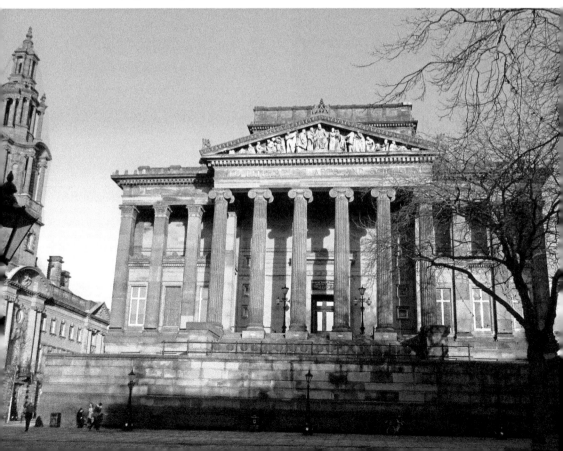

Observers in those early years commented that it had simplicity and symmetry of plan, truthfulness of expression and a great refinement of detail. It was provided with reproductions of the best examples of Greek sculpture, the Renaissance, and the British school of painting – all were well represented in the picture galleries. With an expanding natural history collection and a popular lending library, the roots of its service to Preston had been deeply laid. The building and the contents continue to be the jewel in Preston's crown and long may it continue.

In 1971 it had its façades cleaned to take away the grime of the decades before smokeless zones were introduced. It included a regilding of the letters carved high upon the building. The thought-provoking messages of the gilded letters are quite clear; on the Harris Street side it is written: 'The mental riches you acquire here abide with you always.' On the Lancaster Road side are the words 'Reverence In Man that which is supreme.' On the Jacson Street side is 'On earth there is nothing greater but Man: In Man there is nothing great but mind', returning to the Market Place it simply reads: 'To Literature Arts and Science.'

Indeed, this living time capsule of treasures of the past await you: scientific wonders, literature aplenty, works of art, history and modern technology all available to you inside Preston's magnificent building.

30. Horrocks' Centenary Mill (1895) and Tulketh Spinning Mill (1905)

The significant and preserved structures from Preston's cotton past remain as architectural examples of the bygone might of the industry in the town. Ever since John Horrocks (1768–1804) came to Preston with ambitions to participate in the cotton industry, the name of Horrocks has been writ large in the development of the town.

Horrocks' Centenary Mill on New Hall Lane, a statement of prosperity at the time it was built.

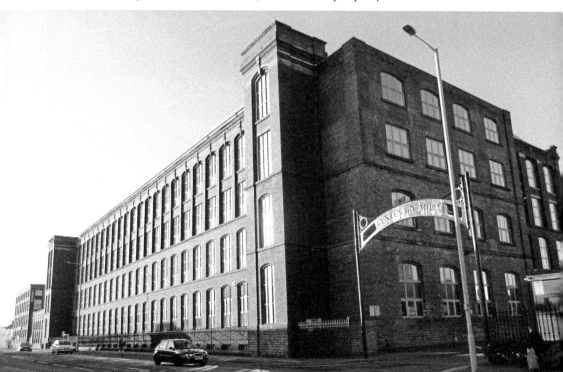

His first building specially erected in Preston in 1791 for cotton working purposes was the 'Yellow Factory' – it was the first of a great mass of buildings that would become part of Preston's life. Little could John Horrocks have thought that a century later another, much grander mill would be built in honour of his achievements during an all too short life.

The new building, completed in 1895 in New Hall Lane, would occupy the site of a large number of cottages where handloom weavers had dwelt. The main building is four-storeys high and 120 yards. It was designed incorporating a revolutionary steel framework which meant it was capable of supporting great weight, and it was called the Centenary Mill.

Besides the necessary preparation machinery, it contained 85,000 spindles and was lit throughout by electricity. With improvements being made at the company's other neighbouring works, the firm of Horrockses, Crewdson & Co. could lay claim to the greatest name in cotton.

Fast forward to 1987 and Horrockses, who had been acquired by J. & N. Phillips of Manchester in 1960, announced they were closing their last working mill in town and moving to Red Scar. The business was by then part of the Coates Viyella group and employed 150 staff; the relocation was expected to cost £250,000.

Naturally, the Centenary Mill had an uncertain future, although hopes of Heritage Funding regeneration were proposed with the building becoming a manufacturing and retail base for local textile. When those hopes were dashed and when most of the mill was derelict and decaying, plans were announced in June 2002 to transform the famous landmark into exclusive apartments. In January 2005 residents were set to move into the former cotton mill which now contained over 200 luxury apartments. The apartments, costing upwards of £100,000, were all sold within six weeks. With a basement car park and a £1 million residents' only gym, it seemed a trendy city dweller's dream.

Alongside the Centenary Mill on New Hall Lane is the former office block. This was used by Preston Farmers for a number of years but was recently converted into a Travelodge, behind which is the Preston Antique Centre.

Another former cotton mill destined to have a long future is the former Tulketh Spinning Mill on Balcarres Road, built in 1905. The five-storey building was constructed around cast-iron columns and steel beams with concrete floors and was clad in red and yellow brick. With a tower, office block, stair turret and engine house, it was an impressive structure. Unmissable also was the tall chimney of brick: cylindrical, tapering slightly and near the top in white brick is the word 'TULKETH'. Around the upper part of the chimney were steel bands and at the top a short tile-clad spire. The chimney would rise to 220 feet in height.

The mill was destined for a lifespan of over sixty years, but in January 1968 it was announced that closure was imminent with the loss of 500 jobs. Fortunately, the Littlewoods catalogue company came to the rescue, although they had much work to do removing the old spinning machines and installing their conveyor belt equipment. What followed was some thirty years of employment and business for local folk.

With the building's future once more in doubt, the Carphone Warehouse stepped in and officially opened their call centre in 2006. The company completely refurbished the old mill and included a restaurant and a gym for employees. By 2008 the number of employees was 1,200 and plans were unveiled for a development of the site which fronts on to Blackpool Road. These ambitions have now come to fruition with a parade of shops and eateries fronting the complex to be enjoyed by staff and public alike.

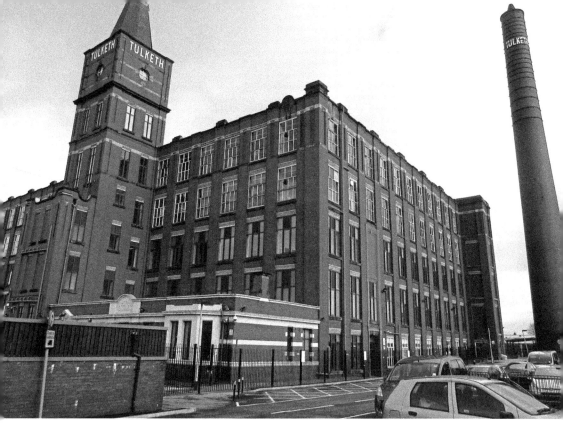

Tulketh Mill, a late arrival in town.

31. Miller Arcade, Church Street (1899)

Nathaniel Miller, born in Ashton-under-Lyne, arrived in Preston in the 1870s and became one of the most successful dental surgeons in the town. His long association with the town council from 1881 was broken only for a short period while negotiations for the site of his visionary building, the Miller Arcade, were going forward. While on a visit to New York he had marvelled at the constructions there and inspired by a book called *Skeleton Constructions* describing the methods of erecting large buildings of steel and concrete, he brought his ideas to Preston.

Having identified a site of some old and insanitary property, he set about the task of creating Preston's first shopping arcade close to the Market Square. When the site was cleared it was discovered that the thick surface of clay made the foundations damp and it was decided to dig down to the sand beneath. This was found 30 feet down and substantial concrete basements were constructed. These were thought to be capable of supporting a structure a couple of storeys higher than the four-storey structure that was built.

What Nathaniel Miller created at a cost of £100,000 was an array of shops with offices above, all on an island site containing shopping arcades in cruciform plan. It is built in brick with terracotta dressings and tiled roofs. The building is in three storeys with cellars and an attic on the south front. There is an entrance in the centre of each side and the rest of the ground floor consists of arched shopfronts. Should you step inside you will find ornate tiling, vintage shopfronts, high glass-panelled ceilings and even a bench or two to rest upon.

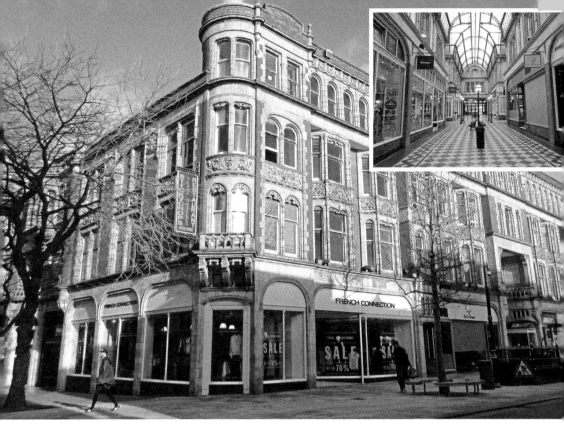

Miller Arcade retains its late Victorian style.

In the early days people came from far and wide to see an arcade that housed shops, offices, a twenty bedroom hotel, dance hall and even Turkish baths. The cellars were used as a cold meat-storage depot for butchers without fridges. A Geisha dance hall, the Kings Arms and the Crown Hotel are all names associated with the arcade. When Nathaniel Miller, who was made Mayor of Preston in 1910, died in 1933 at the age of eighty-three, the arcade was a busy and thriving place. With an unofficial tram terminus at its front, it had no shortage of visitors.

During the Second World War the Admiralty requisitioned some of the offices. Miller Arcade was acquired by the Arndale Property Trust in 1946 and was known as Arndale House until 1972. In October 1986 the arcade was cocooned in builders' scaffolding and a £500,000 facelift was under way by owners Town & City Properties. The arcade was ultimately returned to its Victorian splendour by contractors Bovis Construction Ltd and given Grade II-listed status.

To mark the centenary of the laying of the foundation stone in 1896 by Alderman W. H. Woods, new owners P. & O. Properties held a series of fun events to attract visitors. It seems that Miller Arcade has never had a shortage of willing buyers: it changed hands again in February 2008, acquired for £8.6 million by property firms Kilmartin and The Bluemantle Group, with the arcade at the time having twelve outlets including Millets, Café Manyana, French Connection and the Parmesan and Pepper restaurant. With over 53,000 square feet of retail and office space, the intention was to create an upmarket pedestrian shopping precinct. Currently there are still a number of empty retail units but the arcade itself retains its splendour.

32. General Post Office Building, Former GPO (1903)

The Post Office was designed by Henry Tanner and is in a mix of Renaissance and Jacobean styles. It is built in sandstone and has a large rectangular plan. The building is in three storeys with a basement and attic and the main front is in seven bays overlooking Market Place.

It was opened in August 1903 and served the town for a century until the Preston Post Office was moved to its present location on Theatre Street. A postal system in Preston can be traced back to an earlier recorded building at the southern end of Lancaster Road in the Shambles area of town. A move followed in the early nineteenth century to a building in Church Street, near Derby Street. By the year 1852 a three-storey building in Lancaster Road was occupied for mail purposes. A move to new premises on the north side of Fishergate followed in 1870.

Besides the splendour of the exterior, the internal arrangements had been planned carefully. The ground-floor entrance for the public approached through a vestibule into a lofty hall, along the whole length of which ran a broad counter faced with grills and divisions for class of business required, be it money orders, saving bank, postal orders, postage stamps, letter collection, telegrams or telephones. There were rooms for the postmaster (Mr Kerry), chief clerk, clerks, accountants, engineers, and waiting rooms for messengers. Kitchens, dining rooms, retiring rooms and caretakers' rooms were all prepared on the second floor for the benefit of the staff.

The old GPO building stands proud.

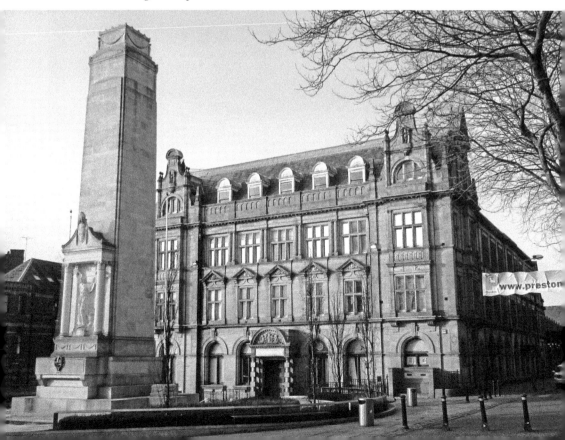

The postal system at that time was flourishing, indeed at Christmas 1903 the new Post Office would deliver 90,000 cards and letters locally on Christmas morning alone. With telegram and telephonic communications crucial to the success of the building, seven cables containing almost 500 wires had been laid into it.

The General Post Office building was, in its Market Square environment, a handy place to buy your stamps, send telegrams, post letters and make a telephone call. The iconic building was given a £500,000 restoration in 1987 with a new public entrance, Edwardian in appearance, at the side on Birley Street and a more spacious interior with modern lighting and décor. At the time it was reckoned to be the busiest public building in town.

It was vacated in November 2002 when the Post Office moved to the Urban Exchange Arcade on Theatre Street. Parts of the building have been used intermittently for art exhibitions and the frontage carries the name Dean Court Chambers – another temporary occupant. Its future is still debated, with conversion to a hotel among the latest options.

33. Sessions House, Harris Street (1904)

In June 1899 grand plans were drawn up for the erection of a new County Sessions House to be erected on land facing onto Harris Street. The structure, with three frontages, was faced with select Longridge stone, broken up with bold columns and pediments. The

Preston Sessions House, opened in 1904.

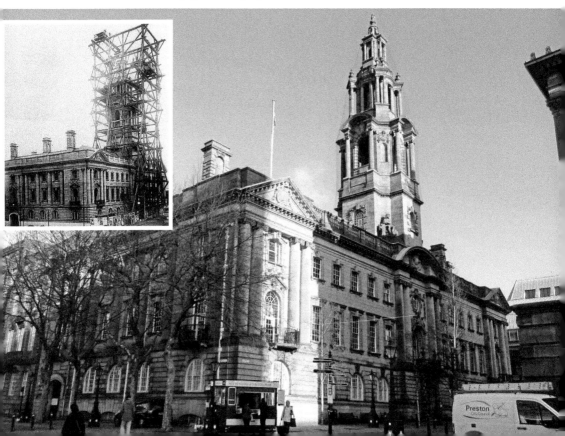

stonework to the windows is ornate in character, with carvings as appropriate. A stately tower of octagonal form with clustered columns rises from the centre of the main façade in Harris Street to upwards of 175 feet.

The main entrance for magistrates, barristers and solicitors was up a staircase of granite steps leading to the second floor, where the courts were situated. The three-storey high structure had cells in the basement for the holding of prisoners awaiting trial, along with warders' room, kitchens, and storage for court records.

The official opening ceremony took place on the 18 June 1904, performed by Sir J. T. Hibbert who praised the new building, which cost £85,000 to construct. He cited the growth of the population of the county of Lancashire and the need to have up to date surroundings. Within a week the first Preston quarter sessions in the new courts took place. For decades the Preston sessions saw criminals from all over Lancashire brought to book, even through the period from 1931, when Preston Gaol was closed, there was a full calendar of cases.

In 1975 it was announced that Preston was set to achieve major Crown Court status with High Court judges sitting in the old Preston Sessions House, following a £500,000 project to provide five modern courts. In April it came to pass, with High Court judges parading to the parish church for a service to mark the occasion.

In 1995 the Lancaster Road courts were closed for refurbishment, coinciding with the opening of the new Crown Court on Ringway. What followed was a £1 million refurbishment including roof repairs, an updated electric system, video links and better security facilities. By February 1997 the proclamations were read and the revamped courthouse was open for business again, to take its place as part of the Preston Crown Court judicial system.

34. The Twelve Tellers, formerly Preston Bank, Church Street, (1907)

The healthy state of banking in Preston was clear in the early twentieth century, when plans were approved to erect a new savings bank on a site in Church Street (previously occupied for many years by the Old Bank).

Mr W. H. Thwaites, an architect of Winckley Street, designed the building and £25,000 was the estimated cost of construction and furnishings. It opened in July 1907 and the style was English Renaissance with a commanding and attractive elevation. Polished Shap granite was used for the base and doorways, with a frontage constructed of polished Longridge stone which had pleasing ornamentation.

The main banking hall was over 60 square feet and 20 feet tall with the banks actuary/secretary Alderman William Bryham Roper having a furnished room on the ground floor. Within the splendour of the new building there would be a committee room, clerks' dining room, strongroom, telephone room and even a cycle store.

Preston Savings Bank had enjoyed very humble beginnings, commencing in March 1816 at the National School, Avenham Lane. Two years later they moved the business to offices at No. 14 Chapel Street. In 1830 the bank moved to No. 7 Lune Street and the capital of the bank had increased from £24 in 1818 to a staggering £41,803. By 1842 the business had capital of almost £90,000 and the trustees resolved to build a new bank in Lune Street – later occupied by the Union Bank of Preston.

Progress was steady and by 1871 the trustees purchased the old dispensary buildings on Fishergate. They were pulled down and a new edifice erected on the site, which opened

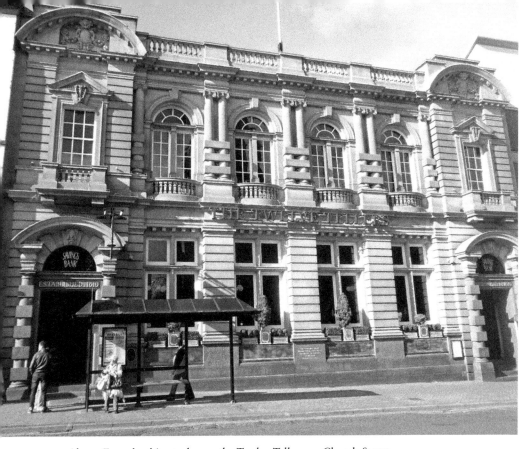

Above: From banking to beer – the Twelve Tellers on Church Street.

Below: The former TSB boardroom.

in September 1872 after having cost £6,500 in construction. That building, in the Greco-Italian style of architecture, was designed by Preston architect James Hibbert.

It seems that banking was popular among Preston folk as shown in a 1875 article entitled 'Thrift' in which the writer remarked thus:

> The inhabitants of Preston have exhibited a strong desire to save their earnings during the last few years, more especially since the last great cotton strike. There is no town in England, excepting perhaps Huddersfield, where the people have proved themselves so provident and thrifty. By last year one in five of the population of Preston had deposited money in the Preston Savings Bank.

The Church Street bank was a popular one for generations of Preston folk and was last occupied by TSB. Once abandoned and neglected, it had an uncertain future until the JD Wetherspoon company bought it and converted it into a public house with the apt name The Twelve Tellers at a cost of £2.5 million. It was opened in January 2015 and retains many of the features from its banking days.

35. Town Hall, Preston Municipal Buildings (1933)

If you walked along Lancaster Road in 1930 you could not have helped but notice the yawning gap between the Preston Sessions House and the Earl Street Police Station. For the enterprising Preston of the period, it became the ideal place to erect the much needed Municipal Building.

It was agreed at a town council meeting in November 1930 to go ahead with the erection of the Municipal Building. The design by architects Messrs Briggs and Thornley of Liverpool for the £130,000 structure, was described as well-balanced and elegant.

Preston Town Hall, Lancaster Road entrance. *Inset*: Inside the Council Chamber.

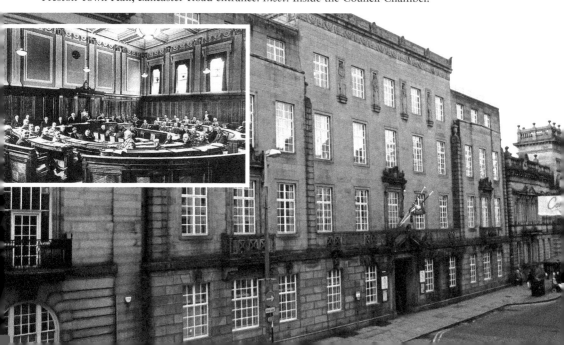

By September 1933 the new building, with entrances on Lancaster Road and Birley Street, built of Portland stone, was ready for occupation. It had light cream walls and huge windows, wide halls and large rooms – be they offices or reception rooms. The ground floor was to contain the Borough Treasurer and the Medical Officer of Health along with their staff. On the second floor the Borough Engineer and the Water Engineer were to run their affairs and on the third floor were the Education Departments. The most significant floor though was the first floor with a Council Chamber, committee rooms and the mayor's parlour. The Council Chamber was described as a room with definite dignity. The benches were made from Australian walnut with a little exquisite carving.

The value of the premises was never more keenly felt than in those dark days after the Town Hall fire of mid-March 1947, which left the old seat of power a blackened ruin. Eventually, in 1972 the building officially became the Town Hall and it is the place where civic matters are nowadays conducted.

These days we have a City Council, yet in keeping with signs outside the Municipal Buildings, we often refer to the building as the Town Hall, not City Hall.

36. Ritz Cinema, Church Street (1938)

These days there is little evidence in the city centre of the days of the silver screen, when Preston had no less than eighteen cinemas dotted about the landscape. In April 1938 the arrival of another luxury cinema was announced – Ritz Cinema.

Nowadays it's the Mokai nightclub.

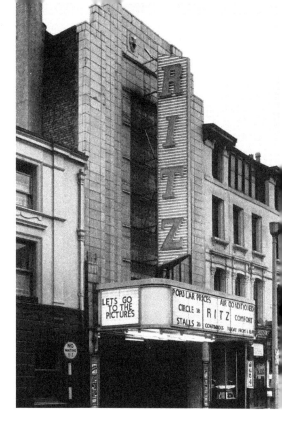

The old Ritz Cinema.

The new Ritz Cinema, built on the site of Goodier's demolition yard in Church Street, had cost £50,000 and had a seating capacity of 1,500. The building was designed by Southport architect George E. Tonge and the main contractor was local builder Levi Yates, who had built the old Tivoli Cinema on Fleetwood Street. The company who owned the new venture were the Preston Palladium Co., who also had the Palladium Cinema across the road in their portfolio.

The whole of the striking auditorium, with a screen 40-feet wide, was built up of steel stanchions and braces supporting the steel mansard roof trusses with a steel-framed floor covered with timber. The foyer was constructed of solid concrete and the elevation on Church Street consisted of cream terracotta slabs with a large glass grill.

What lay ahead was almost half a century of silver screen delights, with many a queue forming to see the latest films. With the decline in the popularity of cinemas attention turned to other ventures: with Scamps discothcque and EMI Bingo sharing the premises, followed in February 1983 by the launch of the Brooks nightclub after a £250,000 revamp, and an Empire Skating Rink appeared for a short while.

Nowadays the premises trade as the Mokai night club and reveals few clues of the building's golden age as a cinema.

37. Co-op Store, Lancastria House, Lancaster Road (1939)

Standing at the corner of Lancaster Road and Liverpool Street, the art deco building known as Lancastria House seems to have an uncertain future. It was opened in 1939 by the Co-operative Wholesale Society and reflected the Co-op's standing in the town.

The Lancaster Road store reflected the Co-op's popularity.

As early as December 1860 the Preston Industrial Co-operative Society held a meeting in the Temperance Hotel in Lune Street with some seventy shareholders attending. Having occupied a shop in Lancaster Road they wanted to purchase that and the adjoining premises. Unfortunately, despite their best efforts, the timing of that particular enterprise was not good with the cotton famine about to strike and thousands of millworkers to be left idle.

Nonetheless, it was still an ambition of Preston folk to set up a Co-operative and in October 1869 the New Hall Lane Industrial Co-operative was opened with a shop at the corner of Geoffrey Street and Carey Street, partly thanks to the encouragement of neighbourhood mill owner Mr H. C. Outram. Sixteen working men had raised a share capital of £20 through weekly subscriptions and on the opening night the shop stocked: three dozen candles, ½ lb of tobacco, 9 lbs of currants, forty onions, forty apples, a tray of buns and teacakes, twenty loaves, a sack of potatoes, 6 lbs of sausages, 6 lbs of black puddings, a slab of butter and one sheep – all the ingredients doubtless for a candle-light feast.

By the end of 1874 other stores had been opened in Adelphi Street, North Road, Ashton Street, Walton-le-Dale, and in New Hall Lane; Co-operative members numbered 1,010 and a quarterly profit of £532 was made on receipts of £6,808.

Those humble beginnings led to a flagship store opening on Ormskirk Road in 1892. Soon would follow upwards of forty neighbourhood stores, all at the heart of the community.

This natural progression led to the Lancaster Road store's unveiling in May 1939. Described as a 'furnishing emporium', it was built in the modern vertical style with the steel-framed structure clothed in concrete and stone. Standing six floors tall, including the basement, it was designed by the C. W. S. Architects in Manchester. The main contractors for the building were John Turner & Sons, based in William Henry Street, Preston.

Like many businesses, the Preston Industrial Co-operative was the subject of takeovers and mergers and by the 1970s it was part of the Greater Lancastria Co-operative Society. In mid-1975 they opened a new food store on Friargate Walk in St George's Shopping Centre, transferring their food trade from Ormskirk Road. In October 1976 they announced the opening of their multi-million-pound superstore in Starchhouse Square, known as Lowthian House, below the Limehouse tower.

Eventually another merger followed with the old Preston society becoming part of the United Co-op group. In 1988 the Lancaster Road store closed down – a fate that had already befallen a number of the local branch stores.

The store on Lancaster Road was extended in 1972 when the Market Hall was completed. It was bought by Preston Corporation with a view of making it part of the Market Hall, but this ambitious plan never materialised and in recent times part of the premises were used by the Preston City Council's architects department. The ground floor was occupied by a Chinese restaurant called Great Times which closed in March 2015 having operated from there since April 1991. As for Lowthian House, that is now the home of Iceland.

In 1979 a sumptuous cellar nightclub named Squires was unveiled underneath the Lancastria Co-op building after a £500,000 investment. Twelve years later the club underwent renovation work, bringing it into the 1990s as Snoopy's became Quincy's. Cameo and Vinyl are nowadays the names over the old Squire's night spot.

A number of old Co-op buildings are dotted around the city, all easily recognisably by the distinctive architectural design of the period. These days the Co-op has handy local stores dotted around the city and these thriving neighbourhood stores replicate the service of old.

38. Odeon Cinema, Church Street (1963)

Cast your mind back to January 1963 when a glittering array of stars, including Leslie Phillips and Stanley Baxter, came to Preston for the opening of the Top Rank Entertainment Centre on Church Street. The new development necessitated the rebuilding of the Gaumont Cinema (previously the New Victoria). Besides the lavish cinema, the Top Rank ballroom was created, along with a restaurant.

A mixture of ballroom and disco dancing every night of the week followed, and partygoers danced the night away to pop, soul and Motown sounds. A number of leading pop groups of the era played the venue, with the dance floor packed. The music of The Hollies, Freddie & The Dreamers, The Searchers and the Rolling Stones gave the place a flavour of the 1960s pop scene. In 1974 the venue was transformed into a heavenly night spot called Clouds. When Clouds' reign ended it was relaunched in September 1989 as Easy Street – the transformation cost £500,000. Of course it didn't stop there, the younger generation could recall the venue's later days as Tokyo Jo's and in October 2006 the venue was launched once more as Lava & Ignite at a VIP event following a spend of £1.5 million on the refit.

The Odeon Cinema which closed in 1992. To the left is the former Woods tobacconist shop.

As the 1960s progressed, cinema was on the wane and in an attempt to woo cinema goers, in February 1970, the Odeon became a two-screen venue with the former restaurant being converted into an Odeon 2. Somehow, the Odeon managed to swim against the tide of city centre cinema closures with the occasional blockbuster drawing the crowds. The inevitable closure came in 1992.

These days a trip to the pictures for local folk means a visit to the multi-screen cinemas down on Preston Docks, which opened in 1990. There has been much talk of renovating the old cinema, but it seems a forlorn hope as the now drab-looking building continues to deteriorate.

Alongside the cinema, separated only by the Old Cock Yard passageway, there is a shop on the corner of Avenham Street that is a reminder of Preston's past. It is now the Lavin Zeus, a twenty-first-century takeaway offering chicken, pizza and kebabs. Nothing historical about that, but if you walk down the side of this three-storey premises you will come upon a frontage that informs you this was once one of the premises of Preston's tobacco manufactures – W. H. & J. Woods. The family business had a tobacco factory in Derby Street. Eventually, in 1978 the well-known Preston tobacco shop closed when a merger took place with a national wholesale tobacco company. The enterprise of William Henry Woods created a tobacco empire in an age when the health hazards associated with smoking were unrecognised.

39. St George's Shopping Centre, Fishergate/Friargate (1964)

One of the significant events in Preston's retail development was the building of the St George's Shopping Centre by the Murrayfield Real Estate Company. The centre, although far from complete, had only thirty of the intended 120 retail units operating when the doors opened in mid-November 1964. Nonetheless, the open for business signs attracted a footfall of 44,000 in the new traffic-free precinct. Bright, attractive shops, colourful mosaics, spiral staircases and covered walkways enchanted the visitors.

Work had begun in 1963 to clear the site for construction with an area of cobbled alleyways, dingy warehouses and antiquated shops known as Bamber's Yard and Anchor Court being swept away. The properties that the developers had to purchase cost them over £1 million. The official opening of the £5 million centre with its own multi-storey car park took place in March 1966, by which time it was a thriving concern.

In 1981 work began on a refurbishment of the centre with a roof enclosing it. This upgrade cost a further £5 million, a sum considered worthwhile by its owners Legal & General. With its admired rotunda it proved popular for displays, exhibitions and entertainment.

By November 2000 the centre was completely transformed beyond recognition and standing three-levels high it was renamed The Mall. It offered thirty-eight new units and the upgrade had required a £28 million spend over the course of three years.

Ownership changed hands again in 2010 for £87 million and it once again trades under its original name. With entrances from Fishergate, Friargate and Lune Street, it is home to a number of leading high street retailers and remains a popular shopping precinct.

St George's Shopping Centre with a new look on Friargate.

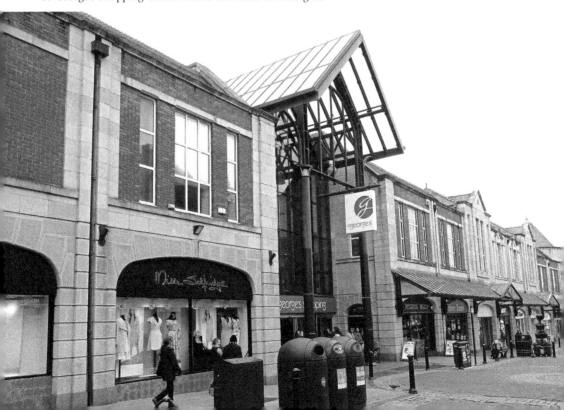

The early days of St George's (inset) and today.

40. Sandown Court Tower Blocks, Avenham Lane (1965)

Preston Corporation's development of the Avenham area began in 1958 when the first significant slum clearance was undertaken within the Brunswick Street area, where 250 densely populated houses were demolished.

These tower blocks were built at a time when the Church of St James still stood in the vicinity on Avenham Lane. The latest building methods were used to construct the multi-storey flats between the old church and Brunswick Street. All the materials for them were factory made and transported to the site for assembly – the system being developed by Concrete Ltd, who produced them in their factory in Leeds. The first phase of the development was the construction of the two tower blocks followed by the building of three and four-storey terraces of maisonettes and flats.

The tower blocks (150-feet tall) took twelve months to build and were completed in June 1965. Being nineteen-storeys high they became the tallest in town, providing 234 dwellings with all the latest heating and ventilation systems. With stunning views and underground garages, the towers had cost £790,000 to construct. Local builders John Turner & Sons had worked in association with Concrete Ltd to ensure the structures were assembled efficiently.

The architect was Keith Scott, a partner in the local firm Building Design Partnership, and he expressed his pleasure as the black and white facings of the structures reached into the sky.

Other apartment blocks in the city did come in for criticism in the decades that followed, but the Sandown Court apartments were thought worthy of a facelift in 2012. The apartments had been sold by the town council to a private landlord in 1981 and energy company Scottish & Southern revealed plans for a £3 million project which included up-to-date energy efficiency, triple-glazed windows and a complete revamp.

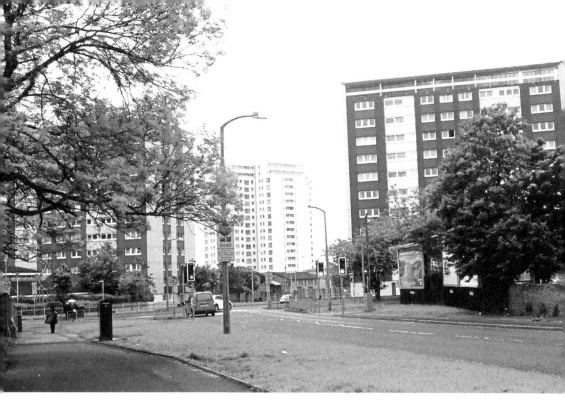

Above: Renovated tower blocks on Avenham Lane.

Right: Sandown Court.

Tenants also occupied the new skyscraper blocks of Lancaster House and York House on Manchester Road – built at a cost of £130,000 and standing eleven-storeys high. Their appearance on the skyline caused quite a stir at the time, but they were knocked down in 2004 and replaced by lower level city-view apartments. The construction of the skyscraper buildings Carlisle House, Lincoln House and Richmond House on either side of Avenham Lane would soon follow, standing twelve-storeys high and 115-feet tall. Still standing today, they have been renovated and cladded to enhance their appearance.

That summer of 1962 saw the finishing touches put to Cumberland House, the first of the three multi-storey blocks of flats built by Preston Corporation on Moor Lane. Cumberland House and its neighbours, Westmorland House and Northumberland House, were structures standing 167-feet tall with each block containing ninety-six apartments. Unfortunately, they also had a relatively short lifespan, being demolished with controlled explosives at the dawn of the twenty-first century after being condemned as dangerous.

41. The Cubic, Market Square/Place (1965)

In 2006 many Prestonians noted with interest the plans for the rebirth of Crystal House as the Cubic. Ever since its construction on the site of the old town hall it held little affection

The renovated structure, now the Cubic, viewed from Fishergate.

from local folk. With a couple of storeys being added it was set to become an even more prominent feature on the Preston skyline.

The demolition of the fire-ravaged ruin of the old Victorian town hall, with its clock tower 176-feet tall and weather vane that added another 15 feet, eventually took place in 1962.

Little time was lost before work started on Crystal House, a structure 164-feet tall. With £400,000 earmarked for the construction it offered space for ten shops with a basement, ground and first-floor accommodation. The second floor and the seven-storey tower provided modern offices. It was completed by July 1964. Take up of the retail outlets and offices was slow with Calgary & Edmonton Land Company struggling to attract tenants. Eventually, a number of shops emerged, including: Brady's Records, which eventually became a HMV store; Colorvision for TVs; the Famous Army Surplus store; Pizzaland; Phildar knitwear; Dixons; even a Pronta Print store.

The renovated structure and newly clad building was completed in 2008 at a cost of £4 million and raised its height to 200 feet. Familiar retailers Slater Menswear, Duncans, Cotswold Outdoors and Moss Brothers occupied the Fishergate and Cheapside outlets, but when Oddbins, Cancer Research and the Burlington's Café departed the scene, plans were submitted in 2013 to rejuvenate the retail outlets on Cheapside and Market Square.

With this work completed, we have on the Market Square side a popular new restaurant called Turtle Bay. Love it, or hate it, this towering building is here to stay, and in truth is now an attractive modern-looking structure that many of us have grown to like.

42. Central Bus Station, Tithebarn Street (1969)

Bus terminals in Starchhouse Square, Fox Street, Tithebarn Street and various bus shelters dotted around the town centre, will be a familiar memory to older generations of Preston folk. All of this changed in mid-October 1969, when the newly erected Preston Bus station opened on Tithebarn Street.

The demolition and construction work had begun in March 1968 on the site, once home to the terraced rows known as Everton Gardens. After eight years of planning, the largest bus terminal building in Britain was unveiled.

The structure was designed by local firm Building Design Partnership with local architects Keith Ingham and Charles Wilson among the designers. One of the construction firms handling the task of erecting the £1 million plus structure were John Laing Construction Ltd. An island concourse reached by pedestrian subways was the vision. Its construction is of reinforced concrete, largely using pre-cast concrete units that were cast in glass fibre moulds on site. The rectangular building is overall some 630-feet long by 88-feet wide.

The development was described as of a brutalist architectural style having a predominance of exposed concrete. Altogether eighty arrival/departure gates were created, all clearly numbered and dedicated, with those on the west side for Preston Corporation buses and those on the east for Ribble Motors & Fishwick, along with gates for tour operators such as Bon Chaunce, Premier & Mercer. With a fleet of ninety-six Preston Corporation buses it was hoped operations would run smoothly from the transport departments within the concourse. New staff canteens and kitchens were just weeks away from completion and it was hoped the buses would be on time like the new

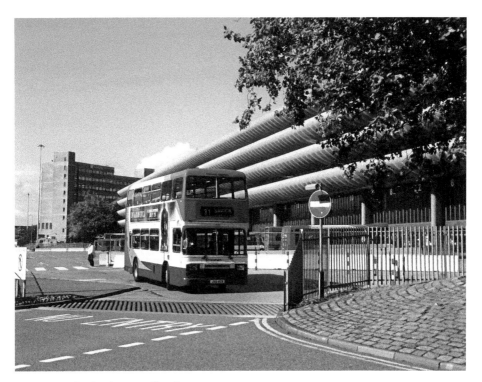

Preston Bus Station is now a listed structure.

The Preston Bus Depot on Deepdale Road, former tram station.

concourse clocks. Above the bus station the development also incorporated a multi-storey car park with spaces for 1,100 vehicles. The new bus station was described at the time by the well-respected Lord Stokes of Leyland as 'a model of imaginative planning as good as anything in Britain and even in the world'.

In 1986 Preston Corporation Bus Company was formed to take over the running of the buses from the council transport department. In 1993 the town council sold the business to its employees with a large number of staff becoming shareholders of Preston Bus. From 2006 Preston Bus and Stagecoach were involved in a competitive struggle for customers, and by 2009 they had sold out to their rivals. The Stagecoach deal was frowned upon by the Competition Commission and in January 2011 the Preston Bus operations were bought by Rotala.

It is true to say the bus station has received plenty of criticism down the decades and closure even seemed on the way as the ill-fated Tithebarn development was planned. Like it or loathe it, the bus station was granted Grade II-listed status in 2013 and recently earned tenth place in a survey to find the best bus stations worldwide. It is now owned by Lancashire County Council who plan renovation work and the creation of a youth zone on the western apron.

The fleet of Preston Bus are still garaged at their depot on Deepdale Road. That building began life as a shelter for the electric trams introduced in June 1904, which were then discontinued in 1935.

On Frenchwood Knoll there stands a reminder of the days when Ribble Motors flourished. In Sept 1937 the company moved into their new palatial offices, erected at a cost of £30,000. The erection of the building was trusted to Thomas Croft & Sons of Preston, built to the directions of Manchester architects. It is a substantial two-storey brick building, with stone facings branching off from an imposing entrance in the centre into two extensive wings.

Having begun life in 1919 with just five Ribble buses, they eventually owned 900 with 4,000 employees and twenty-four depots ranging from Carlisle to Liverpool and Blackpool to Skipton, along with large bus stations in Tithebarn Street, Preston, Chorley and Carlisle. Their buses carried over 2.25 million passengers per week. In 1989 Ribble sold out to Stagecoach and a consequence of that was the closure of the office block. The offices are nowadays home to Virgin Media.

43. Preston Office Centre, Lancaster Road (1972)

Preston realised in the 1960s that more office space was required as the shift from manufacturing to administration was creating the need. By 1970 no fewer than 20,700 people were working in the centre of town, of whom 13,000 worked in offices. As office work grew the need for more accommodation was on the agenda. It was announced in April 1970 that a large development was being planned on Lancaster Road, in the Ormskirk Road and Bishopgate area. It involved the demolition of warehouses in the Old Vicarage, the Congregational Church and eventually some unused buildings of the Co-operative Society.

Three large office blocks thus emerged, one eleven-storeys high, the others slightly smaller. The developers were from Manchester and the architects were local firm Derby

The Preston Office Centre towers above Lancaster Road.

Fazackerley, Wood & Ryan. With a courtyard entrance to all three towers from Lancaster Road, they created an impressive sight. The new offices are nowadays known as Elizabeth House, Red Rose House, Palatine House and Duchy House.

The next phase of this scheme was the construction of another ten-storey block on the corner of Lancaster Road and Ormskirk Road, known as Victoria House. The developer was the Liverpool Victoria Friendly Society and Preston firm Thomas Croft the builders.

By October 1970 it seems that Preston's office tower blocks were to reach even greater heights: work was underway on a £1 million project that would become the Unicentre near Preston Bus Station. Standing at 150 feet it would become the tallest office block in town. The columns were constructed using a Swedish building system known as slip forming. Using this method it was reckoned that thirteen men could erect 13 feet of concrete column within a day, with around the clock work on the Derby Street site.

By mid-July 1974 significantly more towering office space had been built, among them Ribchester House and Marshall House fronting onto the ringway, with the latter being rented out to the post office and Preston Polytechnic.

The days of the dingy office accommodation were over and office workers on the upper floors were able to view an ever rising skyline from their central heated and air conditioned environment.

The Unicentre.

44. Guild Hall, Lancaster Road, and Guild Centre Tower (1972)

There was great excitement when plans were unveiled for the building of the Guild Hall, enabling future generations to enjoy a legacy of the Preston Guild of 1972.

The opportunity to build close to the city centre came due to the recent demolition of the old Ribble Bus Station on Tithebarn Street, along with the ancient passageway known as Wards End which linked Lancaster Road to the bus station. The structure is basically a reinforced concrete building with fair faced concrete exposed in some parts, along with attractive dark red Accrington rustic bricks.

Unfortunately bad weather and strikes delayed the opening until November 1972 – too late for the pomp and pageantry of Preston Guild. The first boss of the Guild Hall was Vin Sumner, who over a fifteen year period brought a galaxy of stars to the complex, among them the legendary Bing Crosby in 1977 and Bob Hope in 1984. Although the visit of veteran Bob Hope, aged eighty-one, brought a loss of £10,000 he delighted the audience of 1,550. When Vin Sumner left in 1986 his vast collection of photographs of stars from his office wall of fame went with him.

A week in September 1977 reflected the popularity of the place. Throughout the week there was a play performed in the Charter Theatre; a youth disco was held in the Grand Hall on the Monday; Tuesday saw the Royal Liverpool Philharmonic Orchestra attract a full house; on the Wednesday night over 1,700 watched the night's wrestling; Bing Crosby appeared on the Thursday, watched by 2,000; and on the Friday and

Preston Guild Hall, set for a twenty-first century upgrade.

Saturday an antique fair was held. Entertainment was plentiful, be it the Olde Tyme Music Halls or the traditional Christmas pantomimes, or rock concerts with stars such Led Zepplin.

Despite the venue struggling at times financially, more decades of entertainment followed. It also became a popular snooker venue for twenty years with the UK Championship being staged in Preston until 1998.

After the arrival of the new Guild Hall and the arcade of popular shops on the ground floor in 1972, the imposing Guild Centre high-rise office block soon followed on Lords Walk which, being fifteen storeys high and 208 feet tall, was even taller than the nearby Unicentre. At the base of the structure is the former Morrison's store which has been abandoned and neglected for many years.

Businessman Simon Rigby took over the Guild Hall in 2014 and acquired the Guild Centre in mid-2015. Ambitious plans for the entire site have been drawn up and work has started on transforming the Guild Hall into an entertainment and leisure centre fit for the twenty-first century.

45. Fishergate Shopping Centre, Butler Street (1986)

Work got underway in 1985 for this shopping centre close to the Preston railway station. Charterhall Properties were the developers and much demolition was required to prepare the site, with numerous properties on Fishergate and Butler Street being reduced to rubble including old Butler Street Goods Yard. The Queens Hotel and the adjoining terrace of

The Fishergate Shopping Centre – a main attraction in the city.

Fishergate Shopping Centre and car park.

shops were demolished. Only one familiar building would remain – the Railway Hotel – which was extended.

ASDA and Debenhams were to be the main attractions among the thirty-five retailers, with 325,000 square feet of shopping space on offer within the £16 million project and an extensive car park provided. Things were certainly in full swing by Christmas 1987 and it was clearly attracting the festive shoppers.

Scottish Amicable acquired the site in 1988 and by 1995 it was valued at £27 million. Debenhams and Littlewoods were the prime retailers, ASDA moved out and Marks & Spencer decided, in 1993, to abandon their prime retail space and move all their business back to their original Fishergate store, which opened in 1929.

By 2004 plans were drawn up to replace the 'dated and shabby' gateway entrance on Fishergate with the modern and attractive entrance that adorns it today. One interesting historical feature that has been retained on Fishergate above the Primark store entrance is the upper frontage of the old town house built by William Cartwright in around 1802, who was heavily involved in the construction of the old Tram Road to Walton Summit.

As recently as January 2016 press reports spoke of a further regeneration of the Fishergate Shopping Centre costing upwards of £40 million. Bigger and better shops, a restaurant and food cluster, along with a multi-screen cinema are the hopes of owner Benson Elliot.

46. Lancashire Evening Post, Oliver's Place (1989)

There was much interest in 1989 when the *Lancashire Evening Post* moved from their familiar Fishergate location to a green field site at Fulwood. The owners, United Newspapers, had ordered four Headliner T70 printing presses from local manufactures Goss Graphic Systems of Greenbank Street wwto be housed in the new press hall, which was 230-feet long by 80-feet wide. The press hall and adjacent two-storey office block had been designed by local architects Cassidy & Ashton and the new centre had cost £28 million. The new printing facility took the name Broughton Printers and the high-tech equipment ensured up to date production.

The LEP and Goss always had strong links, ever since the newspaper's introduction in October 1886. The new facility became a thriving hub of newspaper production with ever-increasing colour content and round the clock working with local and national newspapers rolling off the presses. At its height Broughton Printers employed over 300 staff and printed a dozen newspaper titles each day.

In later years the LEP became part of the Johnston Press group and the printing side of the business, after mergers and takeovers, was part of the Northern & Shell group from 2001. In July 2015 it was announced that Broughton Printers was to close with the loss of ninety jobs, their contract printing being sourced elsewhere.

Plans are going ahead for the LEP editorial staff to relocate to new premises in the city as 'For Sale' signs are displayed outside the premises.

The *Lancashire Evening Post* HQ on Oliver's Place since 1989. *Inset*: The press hall.

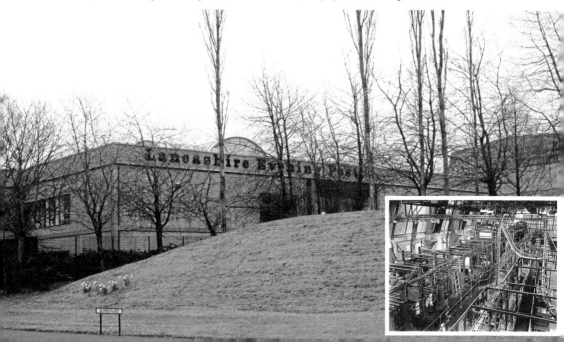

47. NatWest Bank, Fishergate (1991)

We are all too familiar with the great recession and world banking crisis of 2008, when the UK government had to come to the rescue of the beleaguered bankers. Eventually the storm was weathered and despite some banking casualties Preston emerged from it all with a significant number of banks and building societies still trading. Fishergate has always been a major thoroughfare for these financial institutions.

In November 1991 there was much interest when the National Westminster Bank opened their new premises on Fishergate with the Mayor of Preston, Councillor Mary Rawcliffe, in attendance. Prior to the new building's construction, the NatWest had three sites within 250 yards along Fishergate. The scheme brought operations previously at Nos 1, 35 and 99 Fishergate under one roof. The central location was chosen because of the availability of expansion land in Butler's Court at the rear of No. 35. An impressive design by local firm Cassidy & Ashton Partnership provided a five storey operations centre – basement, ground and three upper floors – with an open plan banking hall.

The premises at No. 1 Fishergate were eventually converted into a public house called Wall Street, an apt title for an old financial institution, and traded as such until closure in 2008. These days it is a member of the John Barras pub company under the name Fishers. As for No. 99 Fishergate it has been home to the Skipton Building Society since late 1994.

The NatWest bank centralised operations on Fishergate.

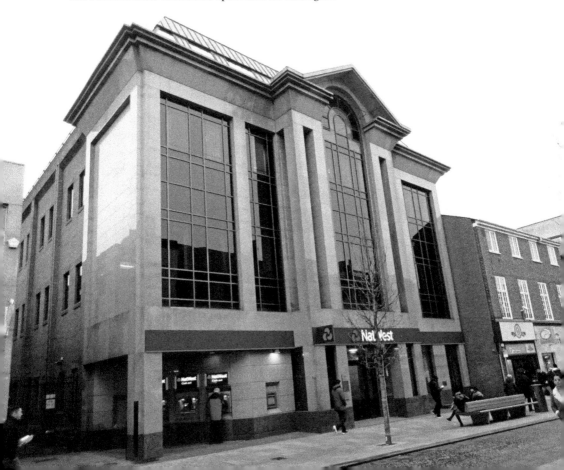

48. UCLAN University Campus (1992)

Needless to say, the name of Edmund Robert Harris should be forever linked with the University of Central Lancashire. For in his Will, published in June 1877, he left the grand sum of £78,564 for the Mechanics Institute and Technical School that would carry his name for decades. Harris' legacy enabled the Victoria Jubilee Technical School on Corporation Street to be built with a grand opening in 1897. It was well equipped with modern machinery for spinning and weaving, all powered by electricity. This building enabled education to flourish in the town and it still stands at the very heart of the university.

Fast forward to 1956 and the growing establishment became known as the 'Harris College Of Further Education' a fitting tribute to Preston's greatest benefactor. With national and local changes in the years ahead the college gained a new status in 1973 when it took the title of Preston Polytechnic. It was renamed again as the Lancashire Polytechnic in 1984, before becoming the University Of Central Lancashire in 1992.

Without a doubt the emerging UCLAN has transformed a large part of Preston and provides employment and education for many in a city that can no longer rely on the threads of a cotton industry for a lifeline.

In recent years numerous UCLAN buildings have been erected within what is an ever-expanding campus in the Fylde Road area of the city.

The first building from 1897 on the UCLAN Campus.

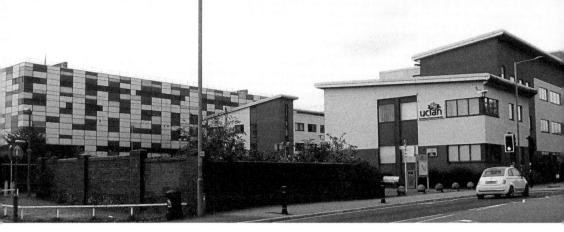

Colourful buildings on Fylde Road reflects the growth of UCLAN.

If proof was needed that Preston, once an industrial and cotton town, is now a university city the developments in late 2015 seemed to simply confirm the facts. The bulldozers, busy in recent months around the Fylde Road area, have demolished some of the familiar buildings of old. This all follows UCLAN's ambitious announcement of a £200 million development proposal for its Preston Campus.

49. Crown Court (1995)

Preston's importance within the judicial system was emphasised in 1995 when the current courts complex was opened on the ringway. Built on the site of the old Saul Street swimming baths at a cost of £25 million, with its opening marked by a procession of judges, it was to become one of the biggest centres on the Crown Court circuit.

The Preston courts have been used for numerous high profile cases in recent years such as the Bulger trial, the Harold Shipman multiple murder case, the Morecambe Bay cockle pickers trial and the trial of Dale Cregan police killer.

Besides its own ten courts and two additional courts within the old Sessions House on Lancaster Road, its circuit judges also serve two satellite courts at Lancaster Castle and Barrow in Furness.

In consequence, hundreds of local folk from around Lancashire are being summoned to carry out jury service. The Crown Courts are situated conveniently close to the Magistrates' Court, which remains another busy place of criminal justice served by trained local people who administer the justice within its walls.

If you are called up to attend Preston Crown Court for jury service chances are that within the fortnight you will find yourself in the jury box and along with eleven others have to decide the fate of the accused. Over 2,000 cases pass through the Preston Crown Court each year with offenders from far and near.

The Preston Magistrates' Court building on Lawson Street was officially opened in March 1972 by the Recorder of Preston, Judge W. H. Openshaw. Sadly, Judge Openshaw was a victim of crime himself in 1981 when he was stabbed to death by John Smith, some thirteen years after sending Smith to prison for theft. The new courts had cost £350,000 and enabled a switch from the old Victorian police courts attached to the old Earl Street police station.

They were also convenient, for the Lawson Street police station opened in 1973 at their rear. The police have now outgrown even that building which has since been converted

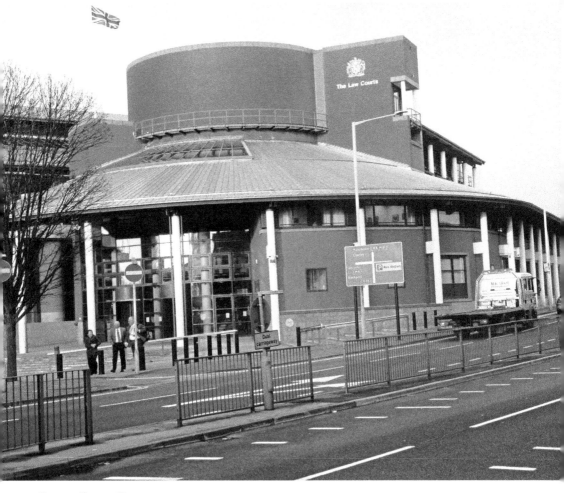

Preston Crown Court.

to apartments. The Preston police took up residence on the old United Utilities site on Lancaster Road North in 2009, taking their familiar blue lamp with them.

50. Masjid-e-Salaam Mosque, Watling Street Road (2016)

The spectacular looking new mosque building, which replaces the original Masjid-e-Salaam Mosque on Watling Street Road, certainly stands out. There was much debate in recent years before planning permission was finally granted and the buildings construction began.

In late December 1970 work was coming to an end in St Paul's Road on the building of a mosque by the Hanfl Sunni Muslim Circle. It was only the second to be built in England in the traditional Islamic style. It was named the Raza Mosque after a famous Muslim scholar, who died some fifty years earlier. The mosque, including its fibre glass dome, was paid for by raising £5,000 from the town's 3,000 Muslim's along with a sum of £20,000 from the Muslim community nationally.

An official guide to Preston, published thirty years ago in 1985, remarked on the religious harmony within the town stating that traditional spiritual links remained, but the make up of religious groups now include Hindus, Muslims and Sikhs as well as small sections of the

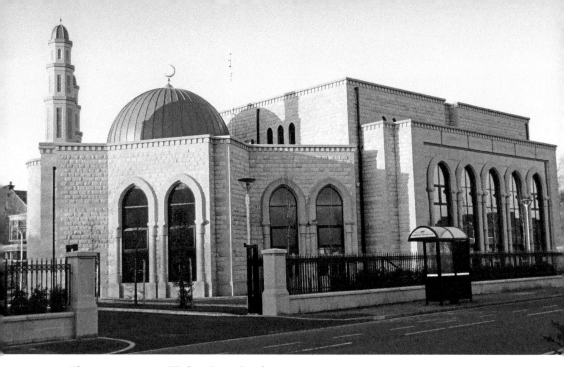

The new mosque on Watling Street Road.

Seventh Day Adventist and Mormons, with the ethnic communities having established their own centres for worship. Reference was made to the mosque on Clarendon Street, saying that it had been purpose built by a community that had begun in the old St James's Vicarage on that site in 1965. The present day Jamea Mosque was built in the mid-1980s, with fundraising among the Frenchwood community and through donations from worldwide believers, covering the £200,000 cost of the structure.

It is true to say, in the multicultural Preston of today, some of these temples of traditional faiths have made their mark on Preston's scene, bringing a new dimension to the architectural surroundings of our city.

Timeline

1400:	Cross/Pedestal at junction of Blackpool Road/Ribbleton Avenue.
1634:	Lower Brockholes Farmhouse.
1638:	Market Place, Nos 33 & 34 – Commercial premises.
1696:	Avenham Walk.
1716:	Olde Blue Bell on Church Street – a thriving public house.
1717:	Unitarian Chapel converted to apartments.
1725:	Chapel of St George – part of Preston Minster.
1728:	Arkwright House – home to Age Concern.
1750:	Church Street Nos 30 and 31 – Marshalls fabrics store and adjacent refreshment village takeaway.
1750:	Friargate No. 11 – three-storey building, a discount jewellery shop.
1755:	Friargate No. 47 – vacant commercial premises.
1759:	Penwortham Bridge – pedestrian footbridge.
1760:	Milestones Garstang Road.
1773:	Old Bull on Church Street, former Bull & Royal Hotel.
1774:	Frenchwood Knoll, Nos 24–27 – a row of two-storey townhouses with Knoll Cottage at the end.
1776:	Old Black Bull on Friargate – a popular public house.
1779:	Walton le Dale bridge – vital A6 throughfare
1782:	Obelisk returned to Market Square 1979.
1789:	HMP Preston, formerly the House of Correction.
1793:	St Wilfred's Church – a popular place of worship.
1794:	Spittall Moss Mill on Fylde Road – now the Ferret public house and a Martial Arts Centre.
1797:	Lark Hill House – now site of Cardinal Newman College.
1797:	Acqueducts over Sharoe Brook and Savick Brook.
1797:	Lancaster Canal Bridges, Nos 14, 15 and 16.
1799:	Winckley Street, No. 11 and Winckley Square No. 4.
1800:	Winckley Street, Nos 5–8 – now a terrace of shops; No. 13 – City Business Centre.
1800:	St James Vicarage & Coach House. Now Arts & Design Centre of Cardinal Newman College.
1804:	Chapel Street No. 1a, Winckley Square No. 1 – St Wilfred's Presbytery
1805:	Winckley Square No.6 – nowadays DWF legal services.
1809:	Former Red Lion/Ellesmere Chambers – nowadays the Popworld public house.
1810:	Chapel Street No. 6 – derelict Sheriff's Office; No. 7 – Brabners; No. 10 – BSG Legal services.
1810:	Ashton House, part of Ashton Park – nursery school.
1814:	St Wilfred's School on Fox Street – later Arts & Media Centre.

1815: Avenham Road Nos 34, 35 and 36 – residential dwellings.
1817: Central Methodists Church, Lune Street – thriving community church.
1818: Moss Cottage on Fylde Road – former doctors' surgery, now the Guild public house.
1820: Cannon Street, No. 36 – Jayne Lousie Health/Beauty parlour.
1820: Ribblesdale Place, No. 13 – Rectory.
1820–25: Fishergate Hill, Nos 1, 2 and 19 – commercial and residential property; Nos 91, 92, 93 and 95 shops/offices.
1820–25: Stanley Terrace, Nos 1–4 – residential town houses.
1822–25: Winckley Square, No. 9 – part of Moore Smalley offices; No. 20 – Charter House, former convent school.
1822: St Peter's Church – now UCLAN Arts Centre.
1822: Avenham Road, Nos 37, 38, 39 and 40 – residential dwellings.
1823: St Paul's Church – now Rock FM radio station.
1824: Corn Exchange – later Public Hall, now a popular public house.
1825: Latham Street, No. 29 – now an apartment building.
1825: Spring Bank, Nos 12–18 – terraced row of town houses.
1825: Church Street, No. 131a – former warehouse, now Chicken Ranch; No. 143 – now Roosterz Kebabs.
1825: Great Avenham Street, Nos 8, 10–14, 16, 18–21, 23 and 25.
1825: Ribblesdale Place, Nos 8 and 9 – Residential properties; No. 18 – town house.
1825: Old Sessions House Stanley Street – now Museum of Lancashire.
1825: Chapel Street, No. 13 – Entwistle Green estate agents.
1825: Old Thorn EMI Works on Fylde Road (former Hanover St Mill).
1826: Carey Baptist Church – originally built for Calvanistic Methodists.
1830: Grimshaw Street, Nos 16 and 18 – town houses now student apartments.

Old properties survive on Church Street.

Acknowledgements

I must acknowledge the help given to me by the staff of the Harris Community Library in Preston and Lancashire County Library who have willingly assisted as I delved into their archives. Their extensive records have made my research that much easier.

My appreciation also goes to the historical newspaper reporters, who in chronicling the events of the past have made this book possible. *The Preston Guardian*, *Preston Chronicle*, *Preston Pilot*, *Preston Herald* and of course the *Lancashire Evening Post* have all provided information from their publications. The Preston historians of old, in particular, Anthony Hewitson, Peter Whittle, Charles Hardwick, Henry Fishwick and William Pollard have provided me with valuable sources of information.

Besides my own collection of images and illustrations, I would like to thank the *Lancashire Evening Post* for permission to use images that are nowadays stored in the Preston Digital Archive. Also, my thanks go to Richard H. Parker, the creator of the PDA, for use of images from that source and to Mike Hill, Communities Editor of the *Lancashire Evening Post*.

My thanks also to Pat Crook for cheerfully checking my text and putting her literary skills at my disposal once again.

About the Author

Keith Johnson is Preston born and bred. His previous works include the bestselling *Chilling True Tales* series of books featuring Preston, Lancashire and London, and the popular *People of Old Preston*, *Preston Remembered*, *Preston Through Time*, *Preston In the 1960s* and *Secret Preston* books. For over a decade he has contributed numerous feature articles on local history to the *Lancashire Evening Post*, and since 2011 has written a weekly Court Archive for the *LEP Retro* magazine.

Keith was educated at St Augustine's Boys' School in Preston prior to attending the Harris College where he gained his qualifications for a career in engineering – spending forty years working for the printing press manufacturer, Goss.